creating *personal* MANDALAS

STORY CIRCLE techniques in watercolor and mixed media

Cassia Cogger

NORTH LIGHT BOOKS

CONTENTS

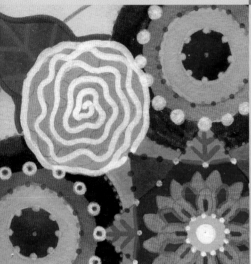

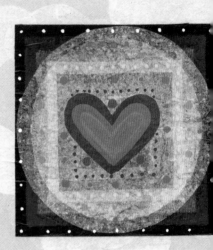

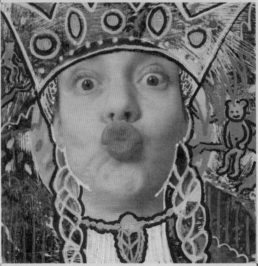

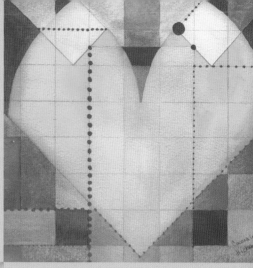

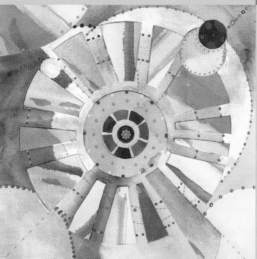

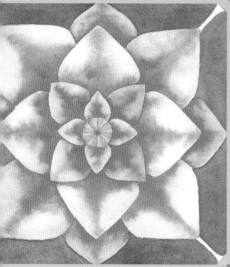

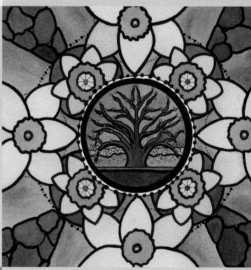

Reconnect to Your Authentic Voice

Reconnect to your voice, explore creative expression, relax your spirit. The time is now!

Does it sometimes seem like life swirls around you, leaving you feeling increasingly lost and slightly disconnected? As if you're not fully or even partially expressed? What if you could be? You can!

Let's reconnect to our authenticity and soothe our souls as we engage in painterly play within the sacred circle.

Regardless of your artistic experience, the pages that follow will guide you to create beautiful work centered around or created within the circle. More important, they will guide you to find the beautiful and sacred within yourself.

The story-circle process returns us again and again to the creative, expressive soul inside we so often forget about. Through a stunning blend of geometry, art-making and visual storytelling, the circles lead us back to center.

With open hearts and inquisitive minds, let us begin!

Mind-Set and Materials

Mind-Set

As with everything, the right mind-set is the most important thing you need for this book: a willingness to dive in and explore, to try new things; a commitment to staying with the processes while also staying tuned in to your own inner muse.

You will explore various techniques and create a number of projects on the following pages. Essential elements of design will be reviewed. When it's all said and done you will create deeply meaningful works of art.

This process is about so much more than just making a pretty picture.

It is about connecting with a deeper part of yourself and working toward fuller self-expression.

It is about experience and journey, not outcome.

It is about reconnecting to your voice, exploring your own unique forms of creative expression and relaxing your spirit.

Please follow the tutorials, consider my prompts and experiment with my exercises, but at the end of the day follow your own creative inclinations. There is no wrong way.

Materials

In addition to a proper mind-set, all you really need to create a story circle is something to make a mark with and something to make a mark on.

In this book I will present exercises with specific materials. You may have something else available you would like to experiment with. Please do! First and foremost, we're here to engage in creative expression and connect with self. Never let materials be a barrier to this process and remember, there is no wrong way!

I love the precision of creating a circle with a compass and dividing it with a sharp straightedge as I build the sacred vessel for my visual story. I can just as often be found drafting the same sacred shapes with dinner plates and cereal boxes or anything else available to me. Try both ways and find out which process appeals to you.

You can use fancy art paper, the kids' construction paper, backs of old documents or plain copy paper. A pencil or a ballpoint pen makes a beautiful mark. Markers and watercolor paints, crayons from my kiddos' coloring box or highlighters from the junk drawer are great sources for color.

That being said, in order to follow along with the playful and painterly exercises, you will need some specific materials. Each exercise has a specific list, though the following are things you will need in general.

General Materials

acrylic matte medium

compass

markers

paintbrushes: 1" (25mm) hake, foam brush, round watercolor brushes ranging in size from 06–10

pens, pencils, paint pens

scissors

straightedge

substrates: watercolor paper, wood panel, canvas

water-based paints (acrylics, inks, watercolors)

water-soluble crayons

WATER-BASED PAINTS

I will be using a combination of watercolors, acrylics and inks.

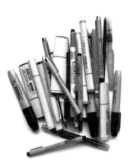

STRAIGHTEDGE

Any straightedge will work. I have incredibly fine rulers from my brief stint in architecture school but more often than not, I can be found using a wooden ruler I have had since elementary school or the edge of the closest book or box.

MARKERS AND PENS

I have a large collection of markers and pens. Make certain that you have 2–3 black pens or markers of varying sizes as well as a white paint or gel pen.

COMPASS

There is something magical about plugging into a point and creating the geometry of the circle as you guide the compass around the center. Choose one that opens up to allow for a 6" (15cm) radius. If precision is important to you, look for one that will lock. I have many and they all work, but my favorite is made by Staedtler, pictured here on the right.

SUBSTRATES

When creating a circle, I enjoy working on a square base. I prefer cold-pressed watercolor paper—140-lb (300gsm), unfinished balsa panels and gallery-wrapped canvases. Each of these surfaces allows for a lot of layering, and the panels and gallery-wrapped canvases are nice for ease of hanging immediately upon completion.

PAINTBRUSHES

It's a good idea to have a 1" (25mm) hake brush and watercolor brushes ranging in size from 06–10 (Royal & Langnickel Aqualon brushes are nice options).

Watercolor Tips

Personal mandala creation does not require any specific materials or specialized techniques. Pencil or pen, paint or collage, really any artistic medium can be used to create a mandala. Markers are a very popular choice for bringing color to mandalas. Watercolor happens to be a favorite of mine, so I wanted to include a few tips for using it, should you decide to give it a try with your own mandalas.

Watercolors are easy to travel with and even easier to clean up. They range from transparent to translucent, leading to interesting layering possibilities in your circle creations. Application can occur through wide, bold washes or tight, minute strokes achieving an exceptional level of detail. This versatile medium allows for a wide array of experimentation and creative expression for all skill levels.

Materials: When choosing to create your mandalas with watercolor paint, you will need the following materials:

Watercolor Paints: These paints are made of pigment and a natural water-soluble binder—gum arabic. They are available in tubes or pans.

Tube paints have more gum arabic, so they are easier to mix and lay washes with. More arabic also means it is easier to correct or lift. You can dry tube paint on your palette and reconstitute it with water for later use.

Pan paints contain a higher pigment content and can be more challenging for laying down big washes. Because they contain less gum arabic, they are more difficult to remove after applying.

If you truly wish to explore the fine craft of watercolor, I caution against using less expensive pan paints. They are often made with a synthetic binder and chemical dyes versus pigment. They may behave differently than traditional watercolor paint, and their permanence/lightfastness is also unknown.

Water-Soluble Crayons and Pencils: Made of the same material as paints—pigment and gum arabic—these contain additional binders to allow them to have a hard consistency suitable for a drawing utensil.

Palette: If you get tube paints, you will want a palette with surfaces or wells for mixing. A foldout variety is best for allowing a surface to mix on as well as for easy traveling. The palette can fold upon itself, protecting your paints until the next use. Unlike acrylic paints, watercolor paints can be reconstituted with water, so do not dispose of them when they dry.

Watercolor Brushes: Watercolor brushes are made of either natural or synthetic fibers.

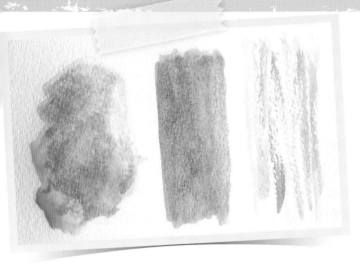

Wet-into-wet, wet-on-dry and drybrush strokes

Techniques: Watercolor is a very flexible medium. There are just a few points of interest as you begin, and there are three ways to apply watercolor paint to the page, all with varying effects.

Soaking and Stretching Paper: You don't have to do this if don't wish; you can simply paint directly on a sheet with no preparation. On occasion you might find you get a few ripples, but as long a you are applying even washes to the page, it should not curl up.

Wet-on-Dry: Wet-on-dry is a wonderful technique for "coloring" things in and creating clean edges. You apply paint with a wet brush to a dry page. Because the page is void of moisture, the paint will not extend beyond the areas to which it is applied.

Wet-Into-Wet: Wet-into-wet is what many people associate with watercolor paintings. You apply wet paint to a wet page or wet area of the page, a wash. Moisture carries the pigment upon its surface, allowing it to spread with varying effect across the area of water.

Drybrush: Drybrush is typically used only for texture work where you use a dry brush and apply paint from your palette to a dry page.

When choosing watercolor brushes, you want them to hold a fair amount of water while also maintaining a fine point. I find black, clear or neutral brush handles best as they distract me less while working.

If new to the medium and purchasing your first brushes, a size 3, 4, or 5 round and a size 8, 9 or 10 round as well as a flat brush for laying down large washes will likely allow you to make most of the marks you will ever want to.

Paper: Paper may be the most important material in watercolor painting. You can work on multimedia paper that accepts water media but will find the best results with watercolor paper. Watercolor paper is *sized*, which means gelatin coating the fibers forces the paint's pigment to stay on the surface of the page versus bleeding in. This keeps your edges crisp and your colors vibrant.

Paper comes in three textures: rough, with lots of texture; cold-pressed, with some texture as it has been passed through a cold set of rollers; and hot-pressed, with no texture as it has been passed through a hot set of rollers. Hot-pressed is ideal for works with lots of detail, whereas cold-pressed and rough allow for a greater amount of texture on the page.

Elements and Principles of Design

Although these exercises are process driven, centered on creating self-connection through uninhibited creative expression, it is inevitable that you will be more pleased with the work if it is aesthetically appealing. To that end I will give a brief and basic mention to important elements and principles of design that will lead you to create beautiful works.

These elements all exist in relationship to one another. Each one can inform or intensify the others.

LINE
A mark connecting one point to another.

SHAPE
A two-dimensional area defined by a boundary—at its most basic form a line—but a shape can also be a change of value, color or pattern.

FORM
A shape with dimension. These three dimensions might be geometric (angular) or organic (more natural in appearance). Form can be implied on a two-dimensional plane through the use of value to suggest shadows and highlights.

VALUE
A degree of lightness or darkness in an element. Through value we are able to delineate line, shape, form and pattern.

PATTERN
The repetition of other design elements such as line or shape. Pattern can be used to enhance surfaces.

COLOR
Light, the part of the light reflected by the object that we see. There are three primary colors—red, yellow and blue—that can be mixed to create other colors.

White can be added to a color to create a tint of it, and black can be added to create a shade. Both tints and shades reduce the saturation or intensity of the original color.

TEXTURE
The surface quality of an object. Texture may be implied by the use of a small-scale pattern on an object or created by the use of art medium itself such as a rough paper or a heavy application of paint.

BALANCE
The distribution of visual weight in an artwork. Balance may be symmetrical like a mirror image, asymmetrical like one large element juxtaposed to three smaller elements or composed along a radial symmetry similar to ripples in water.

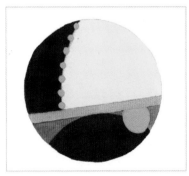

CONTRAST
Contrast refers to differences. It creates visual excitement. There can be contrast among all of the elements of design; many that are easy to create are through the use of line, shape, form, color, value, pattern or texture.

Symbols

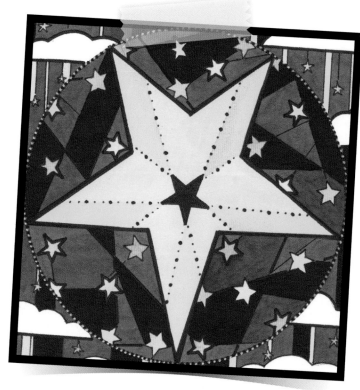

SOME MIGHT say a mark is just a mark. I believe this is not the case. I believe many marks have a story. Many marks fall into the category of symbol.

Symbols are an important part of any visual expression and essential to this art-making process. Symbols all boil down to marks that tell a story.

Some may be very literal and resemble the items they are referencing; some may be very abstract. Symbols are endless. They can be personal, universal or cultural. Marks and meanings specific to you are part of the lexicon of your personal symbols. Universal symbols denote the same thing across cultures. Think about the male and female signs on bathrooms. Cultural symbolism can be found among items like brand logos, religions, etc.

Perhaps you have noticed certain elements that spontaneously repeat themselves in your work, for example, the length, weight or shape of a line, a color, a shape. Perhaps it is the repetitive appearance of certain animals or plants. It is intriguing to dive in to explore the meaning of such marks to see what the messages bring you.

I would like to mention that more often than not I will create a Story Circle knowing very little about the elements I am going to use. After it is completed and I study up on the "language" of a particular flower, symbolism of colors or meanings of animals and shapes I have used, I am often blown away. Nearly every time this has happened the ideas, thoughts or feelings that I have been trying to convey are embodied exactly in the elements I chose to use.

Hanna

This mandala, inspired by a string of words from Hannah Marcotti, is deeply symbolic to me. "When we step into the deepest level of care for ourselves, meaning we claim it, the dreams we never believed could come true start falling as though stars from the sky. Magic. Fierce, fierce, magic."

The image is made up of a circle, a star, clouds raining star drops, the universe in a mishmash of stars all interconnected behind the main one. Planes of space overlapping, becoming one. Everything held together through order and geometry. The image tapping into various symbols both universal and personal.

Creating with symbols sometimes feels as if you tap into a collective unconscious and unknowingly access the language of the universe. (Crazy? A little, but also incredibly powerful and cool.)

A Note on Center

A CIRCLE is a shape created by a line along a set of points set at an equal distance from a center point. Without a center, we have no true circle.

I often remind myself of this as I sit down to work. I take a few moments to find my own center. I clean the surface of the area where I intend to work. I take a few deep breaths. I tune in to the sensual aspects of my materials: the texture of the paper, the smell of the paints or markers, the spring of my brushes. I lovingly prepare my supplies: intentionally sharpening a pencil, tearing down to size any paper I might be using, taking inventory of anything I want to have on hand. If I am searching for inspiration, I might pull a card or look for a prompt. I always prepare a glass of water, maybe a warm cup of tea. Finally I settle down into my body feeling the full support of the room around me and allow my feet to root into the floor beneath them.

I clear a work space both inside and out of myself before I begin the Story Circle process. I find my center before marking the same on the page before me.

I encourage you to experiment with doing the same.

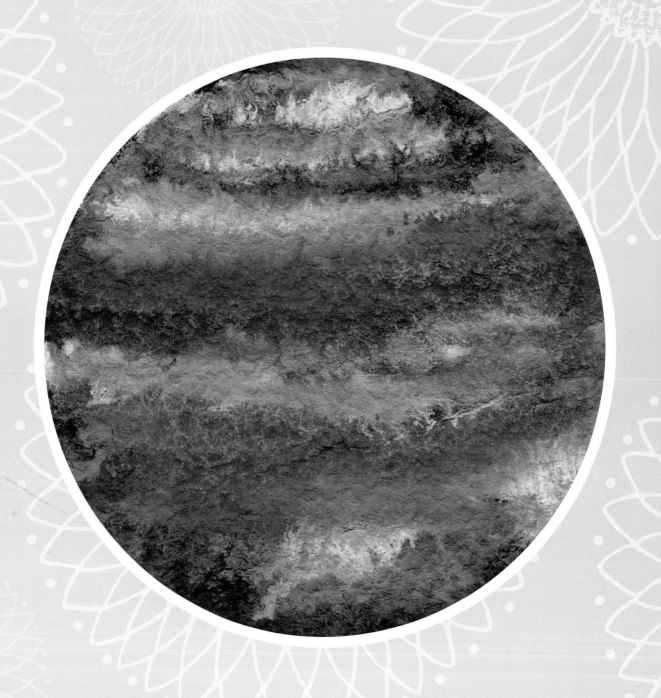

" *God is a circle whose center is everywhere and circumference is nowhere.* —VOLTAIRE

The
Circle

What is a circle? At its most basic definition, a circle is a shape. It is a set of points at a fixed distance connected by a line—a line with no visual beginning and no visual end.

A circle is also so much more.

As you dive into the creative explorations in this book, consider the circle a vessel—a safe container for you to spill your expression out and into. Entertain the circle as a lens through which you can stop and examine how you see and interact with the world by creating within it. Consider the circle as a visual slice of time in which you capture the stories important to you. Utilize the circle as a receptacle for your woes and simultaneously your dreams. Own the circle as an opportunity to ground yourself and be fully present.

Circles are all around you. Stop for a moment and look. It begins with the eyes through which you are looking. They expand out to the mug or glass from which you might be sipping. They are found repeatedly among the natural and man-made objects that surround you.

Now close your eyes and turn inside. Where do you find the concept of circle appearing there for you?

Explore the Circle – A Painting Meditation

As you dive into exploring the circle as a vessel for creative exploring and self-connection, it is helpful to know what this shape means to you. This mixed-media meditation will allow you to do exactly that.

It is likely the symbolism of the circle will change for you again and again. This is a great exercise to revisit regularly to see what it has to reveal.

What You Need

black ink (Higgins: Black Eternal)

compass

cold-pressed watercolor paper, square

hake brush, 1" (25mm)

pencil

permanent markers: light blue or your choice and various width sizes of black

ruler

water

water-soluble crayons: four colors you enjoy and white (I used Caran D'ache Neocolor II Light Blue, Cobalt Blue, Bright Green and Royal Blue.)

watercolor brush, size 08 (Royal Aqualon)

1

Lay your ruler from one corner of the paper to the other, drawing a small diagonal line close to the center of the page. Repeat the process in the opposite direction. X marks the center. Anchor your compass point and draw a circle that fills most of the page; I set my compass to a 3½" (9cm) radius to draft a 7" (18cm) circle. You have now created your vessel!

Using a water-soluble crayon, write "circle?" Close your eyes. Take a moment to visualize a circle and take note of what first comes to mind.

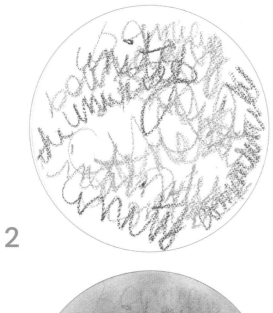

2

Using various water-soluble crayons, start filling in the circle with words that came to you. Once you begin writing, you will be surprised by all of the new words that come to you. Work quickly, paying no attention to spelling or legibility. Allow the words to overlap and fill the space as best you can.

3

Wet your hake brush and apply a thin layer of water (a wash) across the entire circle area. Watch the pigment of the words soften and spread. Rub your brush more vigorously in some areas than others and watch how it affects the color on the page and the clarity of the words.

4

After allowing the first wash of water to dry, take your crayons and write any new words that came up for you. I was surprised to find the word *possibility* came up for me, which is what I wrote here. When you are done writing any new words, look at your circle and add another layer of crayon in a few spaces, increasing the intensity of color in some areas.

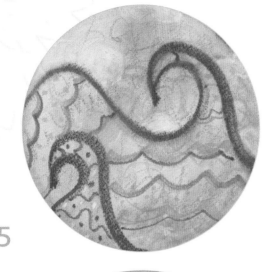

5

Go over the entire circle with a wash of clean water again. Close your eyes for a moment and consider images that have come to you as you have worked with your words and colors, then open them and start to make related shapes on the circle in front of you. I visualized the ocean, so I drew a wave motif.

Notice that the pigment in the crayons comes off more intensely when using them on a dry surface. Continue adding layers of the crayons until you feel the colors of the piece have reached your desired intensity.

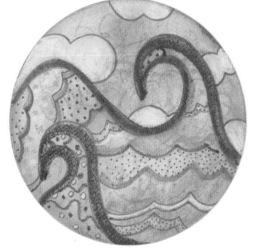

6

After the wash has dried, take your colored marker and begin to work around the image you just created. Call attention to various areas by outlining certain elements. Create contrast by laying down little marks for pattern in others. In this step you are working on creating some crisp, hard edges in contrast to the softer, smudgier look that was just achieved by using the watercolor crayons. Do not outline everything.

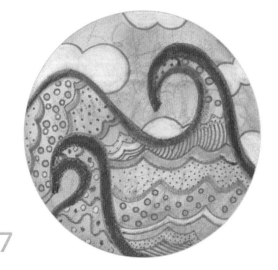

7

Once you have worked around the entire image with your marker, take your white crayon and go back into the light areas you created and lay down more white pigment to create even more contrast.

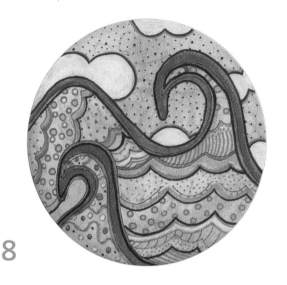

Dip your watercolor brush into your black ink and begin painting in the space around the circle. Using your black markers, begin to emphasize select edges by outlining them and create contrast in areas by laying down little marks, creating pattern.

What did you find as you worked on this piece? This exercise allowed you to experiment with a number of materials while engaging in self-inquiry.

Were you surprised by what came up for you when considering the circle? Did you find you prefer the soft, smudgy, colorful areas or the clean hard-edged lines? How did you like creating tiny patterns in contrast to bigger, open shapes? Does any of this reflect back to you the way you interact with the world?

8

This piece was created using the previous prompts at a different moment in time, another exploration of "what circle means to me." The inquiry on this round led me to life cycles and the image of a seed.

The circle is composed around this idea of the cycles of life and death, beginnings and ends. The seed in the soil, just beginning to bloom. Nearby a fully mature flower, ripe with seeds, that will soon fall back to the same soil.

The flower itself, a sunflower, symbolic of vitality and the life-bringing sun itself.

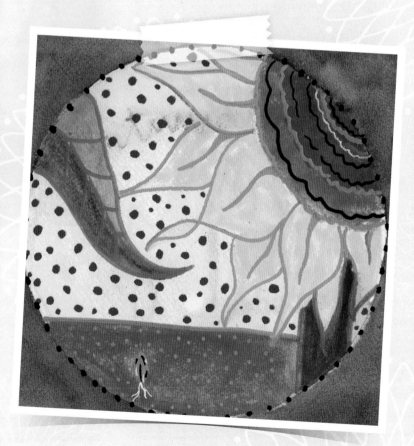

Circle as Container for Self

FOR AS LONG as I can remember I have created circles. As a youngster, the first crayon marks I made were undoubtedly circular in nature. As I grew I left many a telltale sign on my mother's dishes as a result of tracing them with Sharpies. The circle, the shape on which this entire book is based, has always beckoned me.

A line, a shape, a symbol Above all, the circle for me is a vessel, an ideal container for creative expression. A vessel to which you can always turn and reconnect with your long-lost self.

A few years ago it felt like after a life of painting and artistry I had lost myself. I got busy in the day to day, the here to there, the need to go, go, go. I forgot how to create, how to express. I would eke out expression in cooking dinner or coloring with my young children before bed. I never found full expression, never felt real connection.

I wasn't creating artwork consistently or purposefully. I felt I didn't have the time, I didn't have the space; quite frankly, I thought I didn't have the energy. Does this sound familiar?

Through one experience then the next I found my way back to drawing circles. Slowly, I found my way back to myself. With each circle I drew I stepped into a process of reconnecting to self, the creative, expressive soul that lives inside each of us.

Creating within the circle opened the gates to return to myself in a profound way. I am sharing these exercises now because I know they can do the same for you.

Are you ready to spend some time exploring the circle as a universal symbol and begin to tap some of the mystery of its allure?

Symbol Exploration: Circle

ALTHOUGH IT is believed the first drawn circles represented the sun, over time their symbolism grew to be much more vast. Perhaps it began when the first priest stuck a stick in the sand and after drawing a circle around his feet, drew a line between his feet expanding the mark to represent not only the sun but also himself in relationship. For nearly as long, the circle has represented the female element as the shape itself is associated with the womb. Another popular meaning attached to the circle is unity or oneness as there is no beginning and no end.

Other common and universal meanings attached to the circle include Inclusion, Wholeness, Focus, Nurturing, Cycles, Initiation, Everything, Perfection, Centering, Revolution, Infinity, Mobility, Completion, Sun, Moon, Planet, Earth.

Perhaps the most common symbol associated with the circle at present is what many refer to in the western world as a mandala. *Mandala,* loosely translated from Sanskrit, actually is "circle." Mandalas as symbolic diagrams will be discussed at length in a later chapter, but know that each and every circular piece you create is a mandala.

The most important thing we can know about symbolism is that it can be individualized, universal or cultural. This is true even for the most simple of symbols like the circle.

Take a moment and reflect: As you worked on the "Explore the Circle" exercise, what did you find a circle means to you? Did you find what you once might have viewed as a simple shape now holds special personal meaning for you?

Circle as Celestial Sphere

Circles really do make up the world around us. Starting with the electron and spanning out to our earth, the moon that orbits us, the planets that surround us and the sun that warms us, a circle is present. Even the galaxy in which we exist is spiral in framework.

Whenever I set out to paint a simple circle, one with no clear sections or line work, people often associate them with planets. I always view these little orbs as experiments in new frontiers, so perhaps they are planets of knowledge yet unknown to me. This exercise is a greater exploration of materials within the circle that always yields interesting results.

Gather your materials to set out on your own exploration of creating a celestial sphere painting.

What You Need

acrylic inks: two colors you enjoy plus white (I used F&W Velvet Violet and Indigo.)

black ink (Higgins: Black Eternal)

cold-pressed watercolor paper, square

compass

hake brush, 1" (25mm)

pencil

ruler

water

1

Using a ruler and compass, draw a circle in the center of your page. (See step 1 in this chapter's first exercise.) Consider it a planet yet unknown to you. What might it look like?

Using your hake brush, lay down a layer of water across the entire circle. Keep the wash inside the perimeter of the circle. Using your lighter color, drop ink in a few spots, creating a few deeply colored areas. Let it sit for a couple of minutes, then using your hake brush, spread the ink across the entire wash, tinting the entire circle.

2

After the lighter-colored wash is mostly dry, lay down another wash of clear water across the entire circle. Begin by dropping the ink you just used with the dropper, reiterating some of the darker areas you began to establish in the last step. Now drop a different colored ink on top and allow it to radiate out. Using your white dropper begin dropping small amounts of white ink, creating a few lighter areas. Dipping just the tip of your brush into the black ink, work your way around the circle, creating two or three areas of the darkest values.

3

After the previous wash has dried, lay down a final wash of clean water across the entire circle. Using your white ink, place it in areas that need to be lightened, moving it with your brush to spread it and soften the effect. Keep at least one area pure white. Repeat the same process with black ink to emphasize any dark spots.

Now that you have painted your celestial sphere, consider what would a planet of your making look like from the ground? What types of landscapes and life forms would exist? How might it function?

4

FAY STEVENS

Throughout this book I have invited other creatives to share their relationship with the circle. I believe there are so many perspectives and approaches to studying, working with and creating in context to the circle, it will be exciting to explore one each chapter. Here artist and anthropologist Fay Stevens dives a bit more deeply into the circle as symbol.

CARGOCOLLECTIVE.COM/FAYSTEVENS

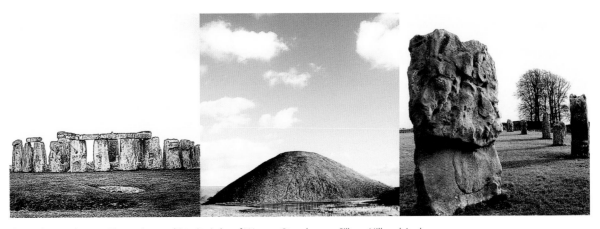

The circle as archetype. The ancient prehistoric circles of Wessex: Stonehenge, Silbury Hill and Avebury.

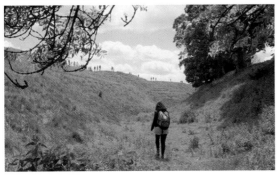

Walking the circular ditch of the Avebury henge. In my rucksack, a kinetic drawing machine that marks my bodily movements as I walk around the monument.

The Circle as Symbol

The circle was a significant symbol for the ancestors who built large, impressive circular features on the landscape. These round monuments were often connected in some way to the cosmos. Stonehenge, for example, is aligned to capture the sun on the longest and shortest days of the year: the equinoxes. An extraordinary circular interplay takes place, a recognition of a circle (the sun), within a series of monumental circles (the henge),

> *Life is a full circle, widening until it joins the circle motions of the infinite.* —ANAÏS NIN

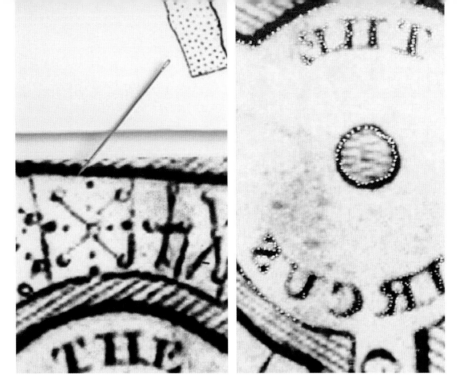

Details of drawings of Stonehenge and the Circus in Bath made by the architect John Wood the Elder (1704–1754), with my pricking out of the features seen here as small circles of light outlining the architectural features.

within a circle (the Earth). Other monuments were associated with ritual, ceremony and on occasion the moon, such as the circle of stones known as "The Cove" within the Avebury henge, a monument comprising a palimpsest of circles of earth and stone. Moreover, enigmatic spherical features, such as Silbury Hill, are round inscriptions on the land, in this case a mound of chalk and earth, located within a complex of circular monuments within a circular valley that marks the confluence of three rivers.

As an archaeologist and artist, my work is informed by these monuments. As a phenomenologist I experience these features in their landscape setting. I walk along, around, within and about ancient circles and the lines that connect them. I draw with kinetic machines, record sound, film my footsteps, write and document senses, creating a palimpsest of spherical inscription within and from my body. I also use maps, drawings and ancient documents as sources for my work.

It is said that John Wood the Elder emulated the design of Stonehenge into his symbolic Palladian architectural vison of the Circus in Bath. For one project, I used his plans of Stonehenge and the Circus and applied an ancient architectural technique to them known as "pricking." This was a method used to copy architectural plans by piercing small holes along the drawn features. In many respects these are drawings made of light, as the copying technique utilizes the light made by the pierced holes and projects an illuminated version of the image. Here I am exploring the technique of pricking as process, visually layering circular places. Through this, I gain a deeper exploration into the haptic qualities of light as it is captured by the pricked architectural features and projected as circular orbs.

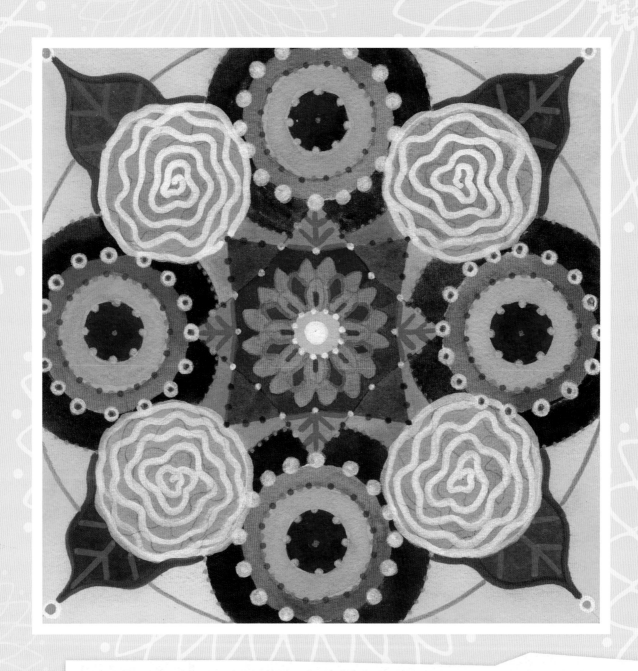

> Each person's life is like a mandala—a vast, limitless circle. We stand in the center of our own circle, and everything we see, hear and think forms the mandala of our life. —PEMA CHODRON

The Circle as a Mandala

What are mandalas? As previously mentioned, *mandala* means "circle" in Sanskrit. Found in various traditions spanning the world at their most basic they are just that, circles.

One could look to the well-known mandalas of Southeast Asia, medicine wheels of Native America, ensõ paintings of Zen Buddhism, the rose windows of cathedrals, the contemporary mandala work introduced to the west by Carl Jung or the adult coloring books found in every bookstore and find commonalities. They are all circles created with intention for specific purposes. All are sacred.

Mandala works are wrought with symbolism, both conscious and unconscious. Some are created as prayer, some are created to assist prayer or meditation; many contemporary mandalas are created as a personal practice to soothe the soul, to calm our systems.

Many traditions state that the mandala is a symbolic representation of the universe. Carl Jung stated that mandalas were actually representations of our unconscious self, and to draw them or paint them allowed one to tap into this and work toward "wholeness in personality," a symbolic representation of self, of our own private universe.

Some traditions of mandala-making follow very stringent procedures that must be followed; others are created from a place of stream of consciousness. All mandalas signify wholeness in some form.

I believe there is no wrong way when creating a mandala and am so glad you are here and ready to explore.

To Rise Up - A Lotus Mandala

A common motif in Eastern traditions of mandala creation is the lotus. The lotus symbolizes enlightenment—the rising up from the muck and the mud to blossom into something beautiful. Often, drafting and painting a mandala guides one in the process of rising up even on the most challenging of days. Gather your materials and prepare to explore this flower full of symbolism and beauty.

What You Need

compass

palette or other surface for mixing paint

pencil

ruler

water

watercolor brushes, sizes 10, 06 (Royal Aqualon)

watercolor paints: Cadmium Lemon, Cerulean Blue (Winsor & Newton); Opera (Holbein)

watercolor paper, cold-pressed, 140-lb. (300gsm) (I used an 8" [20cm] square Arches watercolor block.)

1

Using a ruler, create a diagonal line from one corner to the opposite corner. Repeat this process for the opposite set of corners. These lines have identified the center of the page. Identify the midpoints on each edge of your sheet and connect these points to divide your page into eight segments.

2

Anchor your compass to the center point and draft four concentric circles varying at least slightly the space between each one. I drafted circles with the following radii: ⅜", 1¼", 2", 3⅛" (1cm, 3cm, 5cm, 8cm).

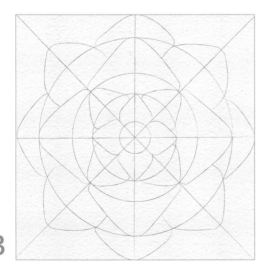

3

Using the intersecting lines and circles as a guide, draft your lotus flower. Create four petals at each circle. Create an additional layer of petals at the outermost circle. In the innermost circle, divide your eight sections in half with a line creating an intricate center portion of the blossom.

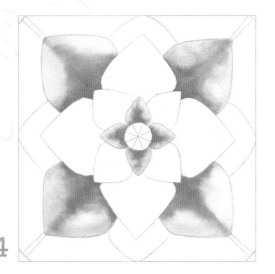

Create one final circle. I used a radius of 5⅛" (13cm), cutting in just at each corner of the page to mimic lotus leaves. Draw radiating lines out to each corner. Erase any pencil lines that do not relate to the final lotus image.

Dip your brush into clean water and paint the center four petals and four petals along the fourth layer of the blossom with a clear wash. Fill your brush with Opera watercolor and gently touch it along the bottom edge and center section of each wet section. Allow the paint and water to interact and the color to radiate out.

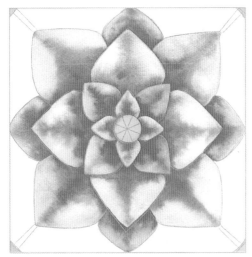

Allow the petals you painted to completely dry, then repeat the process with the remaining petals. Make certain to keep wet petals separate from one another to achieve a nice crisp edge as they dry. Lay a wash of Cadmium Lemon down in the center circle of the flower as well as the corner sections of the sheet.

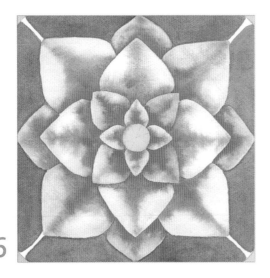

Mix Cadmium Lemon and Cerulean Blue (or other colors of your choice) to create a green wash to fill in the areas surrounding the lotus. Leave the thin white lines radiating from the lotus out toward each corner.

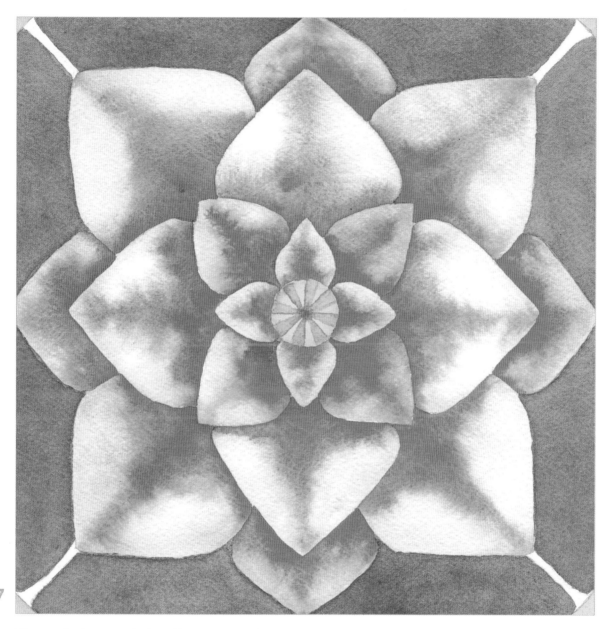

7

Mix a touch of your petal color with your center color to create a slightly darker version of the center wash. Paint alternating sections of the center circle, creating a pattern to define each petal.

Consider yourself the lotus. What is the mud and muck from which you would like to rise above?

A Move Toward Mandalas

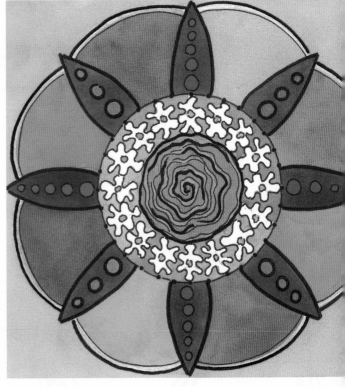

The first Story Circle I created was inspired by some flowers sent to me by my friend Patty.

The colors and spaces are soft and sweet, almost quiet on the outside. As it works toward the center, it becomes busier and bolder; there is a lot of exciting stuff going on. The black outlines were added last to add a little edge to this sweet piece.

The daisies, which form a ring around the center carnation, symbolize purity, innocence, loyal love, beauty, patience and simplicity. The center flower, a light red carnation, symbolizes admiration. It was with the creation of this piece that I first realized the power of using the circle as a container for creative expression and symbolism to share a story visually.

THE PRACTICE of creating mandalas slipped into my life quite unexpectedly, or so I first thought.

It started after a show of work exploring sacred geometry and the heart. I became ridiculously attached to my compass, ruler, kitchen table and mechanical pencil.

The process of drafting filled any available space in my day. It became the place I found my breath.

I was completely energized by what seemed a brand-new process of communing with self. Yet, as I worked on, in and with it, I came to realize it wasn't new to me at all.

For decades I had pulled out cups and plates, buckets and quarters to trace circles in various sizes. I started my university years as an architecture student at the University of Colorado's Program in Environmental Design, drafting hard line after hard line. I have vivid recollections of painting an intricate Aztec calendar for Spanish class in high school. I studied Mithila painting in Nepal and even explored Thangka painting instruction when I lived there. I had been dabbling at the edge of this process for years.

As you look back, do you recall similar creative urges? The tracing of shapes. The drafting of lines. As you move forward on this exploration of drawing circles and making mandalas, pay attention; perhaps you'll find you are returning to old practices in new ways. Perhaps you'll find yourself answering internal longings to create order through geometry as you find union between your internal and external experiences.

Symbol Exploration: Tibetan Buddhist Mandalas

MANDALA SIMPLY means circle. Some consider these circles to be cosmic maps; others see them as representations of the unconscious self. One common mandala motif found in many Eastern traditions is a square with four gates surrounding a central point.

The creating of the mandala is a sacred ritual in these traditions and performed only by specially trained individuals.

Symbolism varies by tradition, but mandalas with a square and four gates are said to represent cosmic diagrams and the square a two-dimensional depiction of the palaces of sacred deities. The gates can symbolize the four directions, the four quarters of the world or the four boundless thoughts in Buddhism. What might the four gates represent to you?

Heaven and Earth Mandala

Many mandalas consist of a circle in relationship to a square. This might seem purely practical or driven by radial symmetry. Aesthetically, a circle in a rectangle just operates differently than it does in a square. However, the symbology of these two shapes in relationship is also very important.

In many traditions the mandala circle is said to be a cosmic map, representative of heaven; the square a symbol of earth. Circle in the square; heaven and earth together.

If you add Jung's theories to the mix, you could view it as yourself and the world that surrounds you.

This exercise follows a rainbow pattern. As with all exercises in this book, feel free to work with a different palette of your liking, substituting colors as you wish. Collect your materials and begin to explore.

1

Cut a 6" (15cm) square from light blue tissue paper and cut several cloud shapes from white tissue paper. Using a foam brush, apply an even layer of matte medium to your canvas and lay down the layer of light blue tissue paper on top of it. Still using your foam brush, gently smooth the tissue paper onto the surface of the medium and canvas while simultaneously applying another thin layer of medium over the top. While the top layer is still wet, layer your cloud cutouts at various places across the canvas, allowing some to overlap. If you want some clouds to be more opaque, layer one cloud directly over the top of another. Using your foam brush, gently smooth the clouds completely onto the surface and seal the piece with another layer of matte medium.

What You Need

- acrylic matte medium
- canvas, 6" x 6" (15cm x 15cm)
- cutting board
- foam brush
- paint pens: rainbow of colors plus white (Posca)
- razor blade or scissors
- straightedge
- tissue paper: rainbow of colors, plus white and black

2

Cut the rest of your tissue paper in preparation for a swift gluing and layering process. Measure out and cut the following from the colored tissue papers: 4½" (11cm) black square, 4" (10cm) red square, 3½" (9cm) orange square, 3" (8cm) yellow square, 2½" (6cm) green square, 2" (5cm) blue square, 1½" (4cm) purple square, a white circle with a 4¾" (12cm) diameter, a white circle with a 3¾" (10cm) radius and a red heart approximately 2" (5cm) at its widest point.

Following the same process as above, using a foam brush, apply an even layer of matte medium to your canvas and lay down the black square in the center of it. Using the foam brush, gently smooth the tissue paper onto the surface of the medium and canvas while simultaneously applying another thin layer of medium over the top. While the top layer is still wet, center and place your red square and gently smooth it down while applying a bit more medium. Repeat this process, working from orange>yellow>green >blue>purple>big white circle>small white circle>heart. Apply a final coat of medium over the top and allow the piece to completely dry.

3

Once your piece is completely dry, have some fun making marks with your paint pens. You might enjoy making various sized dots along the identically colored layers for the rainbow section, or in the outermost square using a white pen on the black surface to create a strong contrast in juxtaposition to the rest of the piece. Finally, I used a red pen on the red heart to create subtle variations within that shape.

How do you view the relationship between heaven and earth or yourself and the world that surrounds you?

KATHRYN COSTA

Kathryn Costa, author of *The Mandala Guidebook,* shares a bit about her personal purpose and process of making mandalas.
100MANDALAS.COM

Mandala Journey

My phone pings and I have several notifications: new e-mails, a text from my son, likes and comments on Facebook and someone new following me on Twitter. Ping, ping, ping. All day long I'm reminded of how I'm connected to people all over the world. My to-do lists are always crazy long and my creative mind pings and fires with idea after idea. I love it all—the creating and connecting—but it gets exhausting at times and leaves me feeling scattered.

My mandala practice is a place to refresh and get grounded. I pull out a piece of paper and a few tools: a mechanical pencil, Fineliner pen, ruler, compass, protractor and some colors. I may have an idea in mind when I start, a color scheme or shapes and patterns. After drawing several circles on the page I begin to add shapes row by row. My shoulders soften and my breath deepens.

I pause often as I work to consider how the mandala is taking shape. Sometimes I goof with a line or pattern and I need to change direction with the design. Often in the middle of the process, feelings of resistance show up. I've come to expect this and respond the same way with reminders to forge ahead, stick with it and give it a chance to see where it will go. I ask myself, *How many times have you felt this way and you loved the results when you didn't quit?* I press on and soon get lost in adding the details in little marks, patterns and colors. Each time the mandala design emerges seemingly on its own and I'm there to witness it. Experience has shown me how easing up on my perfectionist ways makes for a delightful journey. Now when I sit down to draw a mandala, I'm eager to see where the journey takes me. It's always a surprise.

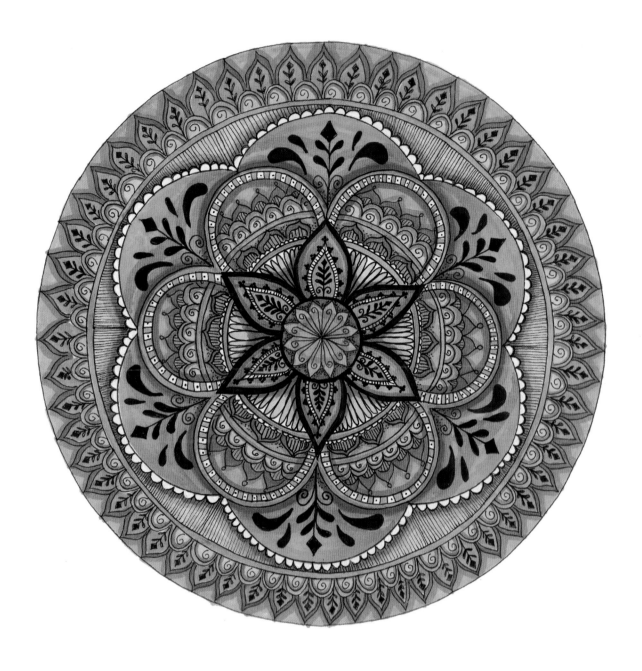

This mandala looks like a flower in full bloom. At the time I created it, I was developing and launching many projects. I associate the color orange with creativity; it combines the passion of red with the joy of yellow. Throughout this design the orange is embellished with floral motifs illustrating my many projects. The contrasting calming blues and greens remind me of how I need to balance my busy production schedule with relaxation, exercise and healthy foods.

Materials used: Micron Fineliner pen, Copic markers

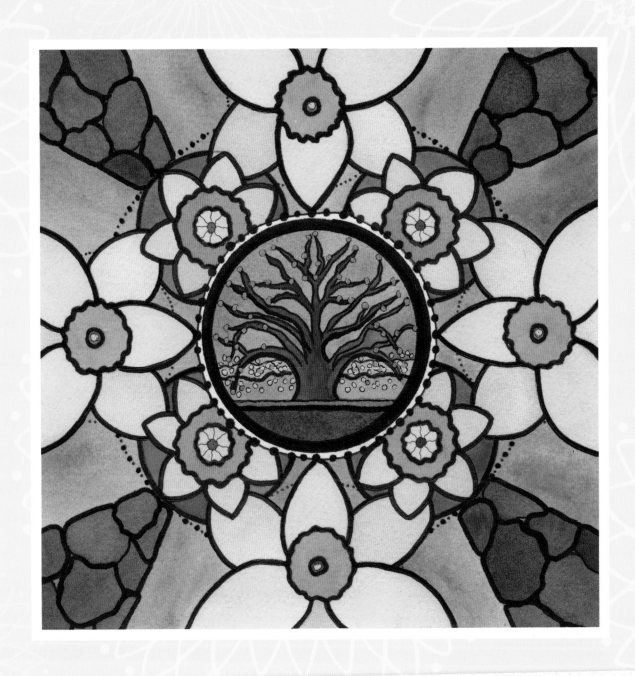

After nourishment, shelter and companionship, stories are the thing we need most in the world. —PHILIP PULLMAN

The Circle as a Story Slice

Just as the slice of a tree trunk captures and shares the history of time, I love the idea that we can create circular artworks that do the same. Even more exciting than the capturing of the life history of something is the possibility of using the circle like a magnifying lens or a two-dimensional snow globe where we are able to capture a static scene to celebrate, commemorate or explore a moment.

My Story Circles began as simple paintings done in a circular format celebrating specific people and special moments. Little capsules capturing my visual and symbolic memories. Over time they evolved and became a mechanism for exploring and releasing stories I held from my past as well as a vessel for me to visually explore my future.

Story Circles are an opportunity to create with intention; to document, explore and process an experience.

◄ **Persephone** Created as an actual depiction of the memories of a day trip visiting Block Island and my friend Persephone. My kiddos and I took the ferry out, passing many stone seawalls along the way. We explored the island and continued to see wall after wall. Eventually we ended up on a piece of conservation land that was planted with thousands of daffodils in full bloom. In the middle was a lone tree. It was a very special place and moment, exploring this area with a good friend, watching the kids revel in the surroundings; and that tree . . . so strong and solid.

Story Circle

Creating a Story Circle is one of my favorite ways to process an experience. I love to revisit moments and identify key components of the story and document them visually as part of a mandala.

In this exercise I am documenting the story of a day of snorkeling, a trip spent expanding limits and searching for solutions. The focal point of this journey for me became a conch shell and so it became the same for this circle.

Is there a story of a time or place you would like to share visually? Identify a key component to serve as your focal point and let's get started.

What You Need

compass

paint pens: colors to express your story (I used Posca's Yellow, Mint and Peach.)

palette or other surface for mixing paint

pencil

ruler

water and water container

watercolor brush

watercolor paints: colors to express your story (I used Winsor & Newton's Cadmium Lemon, Cerulean Blue, Indigo and Holbein's Opera.)

watercolor paper, cold-pressed, 140-lb. (300gsm) (I used an 8" [20cm] square Arches watercolor block.)

1

Find the center of your square piece of paper by drawing a diagonal line from one corner to the other. Repeat this process on the opposite corner. The intersection is the center. Anchor your compass to the center point and draft a circle with a radius of 3¼" (8cm).

2

Create a border for your image by drafting an additional circle from the center point with a radius of 2¾" (7cm). Draw a horizontal line across the circle approximately one third up from the bottom. Think of this as the horizon line of your story's scene. Draw the central element of the story along this line; in my mandala, it is a conch shell. Draw any elements you want in your composition. I drew a sun peeking out of the upper corner, laid out a few additional horizontal lines to create the ocean and beach, and sketched out a repeating wave pattern along the outer border.

3

Saturating your brush with water, dip it into the main color of your composition and create a flat wash of paint in the appropriate areas. Allow this wash to dry. I painted the sky and the sea with Cerulean Blue.

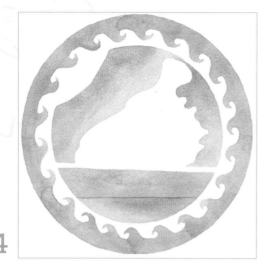

Identify the next color and area you would like to paint and do so. Allow these areas to dry. I mixed a touch of Cadmium Lemon with Cerulean Blue to create an aqua to paint in the upper portion of the ocean and the wave pattern at the outer ring of the circle.

4

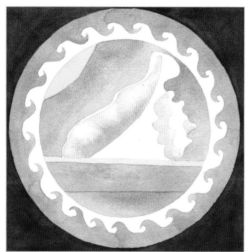

Continue painting each area of your piece, allowing each shape to dry completely before painting adjacent ones. I painted the sun shape Cadmium Lemon. I mixed it with Opera to create a soft peach hue and used this to paint a line of sand across the top of the ocean and two separate sections of the spiral top of the shell. While my brush was still loaded with this color, I ran it across the big upper section of the shell, then immediately dipped the brush into water to fill in the remaining space so the color softly spread down. I dipped my brush into Opera and ran it along the opposing edge, allowing the bright pink to softly spread up.

Consider framing your story in a dark color to make it pop out. I did this with a small amount of Cerulean Blue mixed with Indigo.

5

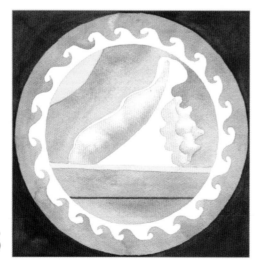

Continue painting one section then the next, allowing each to dry completely before the next. I painted the remaining sections of the spiral and the top edge of the shell, then took a small amount of the Cerulean/Indigo mix and ran a thin line of paint between the Cerulean Blue and aqua sections.

6

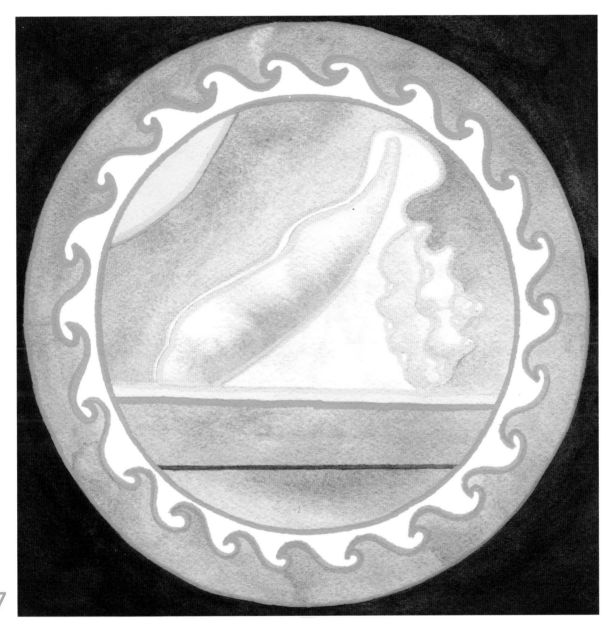

7

Finish painting any unfinished sections and allow them to dry. Take your paint pens and, starting at the outside of the circle, outline various shapes in a coordinating color.

What story did you tell? How did it feel to retell it in a visual format?

Story Circle Examples

I CAN'T state enough how much I love taking an experience and visually expressing it within the container of the circle. Here is a gallery of various pieces of my work to see some of the possibilities. Some are wrought with symbolism; others simply explore colors or shapes evocative of a place for me.

The act of taking an experience and visually expressing it within the container of the circle is incredibly exciting. Possibilities are endless. You can create pieces wrought with symbolism, detailed drawings or simply explore colors or shapes evocative of a place or time that is special for you.

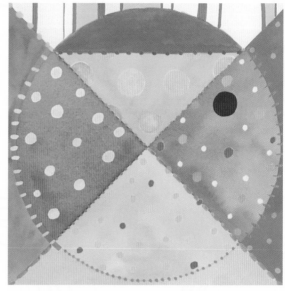

▲ Popsicle

A much simpler story and an abstract design.

The colors here were influenced by my then-toddler-son's snack. It was created one incredibly hot day while we were traveling. After a full day of running around, we arrived back at my mom's house. I handed my two-year-old a cold snack as I started my daily mandala. Looking for inspiration, I settled on the Hawaiian Punch Bomb Pop he was eating and voilà . . . a memory from that summer day visiting Colorado.

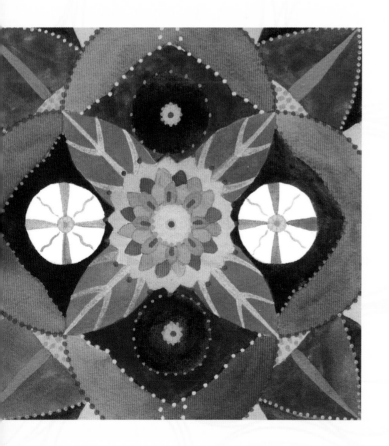

◄ Deb

This story circle commemorates the moment I created it. The elements were not chosen in advance but ended up having strong symbolism for me.

It was created while my mom, Deb, was out visiting from Colorado. She sat with me at the kitchen table as I drafted and drew, then painted piece by piece. We sipped red wine and chatted as I worked. I was drawing with no direction, finding inspiration wherever I looked. I liked a strawflower in a bouquet nearby so I started with that. I drew some circles and bold geometry, then decided they must be morning glories. Mom recognized them before I even painted them as morning glories too, and so they were. A Story Circle I can look back on and remember the time, the place, the conversation as it unfolded, this time as I painted it.

Symbol Exploration: The Symbols in a Story Circle

INSTEAD OF exploring a single symbol in this chapter on story, I want to share a complex Story Circle, the process of designing it and explain how all of the symbolism operates within it. You will note some of the symbolism is universal; other meanings are assigned personally by me.

Two dolphins danced out of my pencil and onto the page. The magical creatures who had shared their waters with us for the previous week. Symbolic of wisdom, peace, play and communication.

A big purple fan of seaweed sprung up. The kind that allured me each time I saw them in the water. The kind that swayed gently beneath me, just as my body did, as we swam above a shallow reef the day before.

Another seaweed. Seen again and again as we snorkeled. Rooted firmly yet completely relaxed. Exactly how I yearn to be.

The conch. This element was such a huge part of the trip for me. Speaking of finding one on the beach our first morning only to walk there and see it waiting. Swimming above hundreds of them later in the week and later facing my fear and diving down to gather one myself. A totem of my ability to surrender as I slowly swam back to the boat and someone offered to carry them for me, and I happily received the gift of assistance. Symbolic of victory over suffering, which is precisely what this trip offered. Spirals in nature mirroring the spirals that presented themselves again and again on this trip.

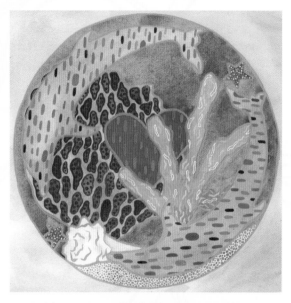

I created this piece on my final full day in Bimini. I woke early and headed outside to the tables overlooking the bay. I sat and found my center, both on the page and in myself. I drafted my circle, symbolic of the container of people, space and experience in which I had existed for the previous six days.

Starfish spotted at random, sprinkled upon the sandy ocean floor. Connections to heaven. Symbolic of dreams come earth-side.

In the center, **a heart**. Symbolizing myself and all the wonderful people I shared the experience with. Universally tied to joy and compassion. Also an inverted triangle, a receptacle, open for love to flow in and to be held. The pattern of the dolphins layered upon the surface of the heart because we are all different for having spent time with them.

Geographic Story Circle Collage

Do you ever accumulate papers or other artifacts as souvenirs of a place? Making a mixed-media Story Circle is a wonderful way to put some of these mementos to creative use. In this exercise I use an old neighborhood map to commemorate a neighborhood we used to live in.

Perhaps you have a map or other paper reminding you of a special place. Go find it, decide if you want to use the original or a copy and dive in to the exercise.

What You Need

- assorted collage papers and elements
- awl
- compass
- embroidery thread
- glue stick
- map of an area that means something to you
- marker, color of your choice
- masking or artist's tape
- needle
- paper (as a base for collage)
- pencil
- scissors
- water and water container
- watercolor brush: size 10 (Royal Aqualon)
- watercolor paint: one color (I used Winsor & Newton's Cadmium Yellow Deep.)

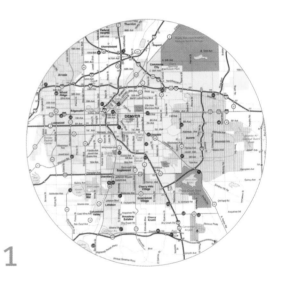

1

Use your compass to draft a circle with a radius of 3⅝" (9cm) over the portion of the map you wish to include and cut it out. Completely coat the bottom side with a glue stick and center it on your base sheet. Smooth the circle down from the center out to prevent air bubbles.

I selected a map of an old neighborhood we used to live in during our years in Denver and cut out a section that included our old address. What area would you like to commemorate?

Identify and trim any collage elements you wish to include in your circle. Completely coat the undersides of your elements with a glue stick and place them in the circle. Smooth out any air bubbles. I created a small house shape and cut out a rainbow and cloud graphic I found on a scrapbooking sheet. Are there symbols that relate to the geographic location you want to capture in circle form?

2

Draw a few linear elements within the circle with your marker.

I used a purple marker to create lines symbolizing mountains to the west of the city. Is there a geographic element local to the area you are depicting that you could represent in simple lines?

3

Create a small shape with strong contrasting color to create a focal point for your circle. Repeat the gluing process from previous steps. I created a bright red heart out of a tiny scrap of found paper. Is there a feeling about the location you are sharing you can convey in symbol?

4

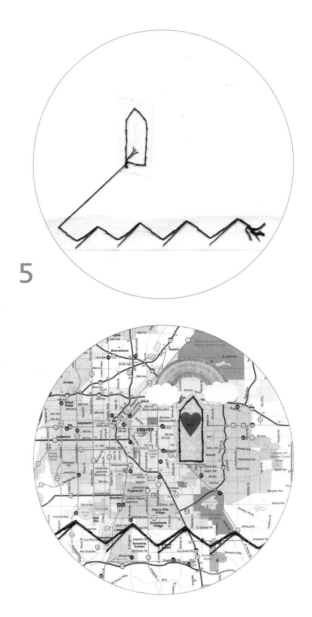

5

Select a few areas you would like to accentuate with embroidery stitches and create a series of small holes with an awl in a line spaced every ¼"–½" (6mm–13mm) or so. Flip the paper over and apply a layer of tape over all of the holes. This will reinforce it in preparation for stitching.

Place the embroidery thread in the needle and using a straight stitch, work down your lines in one direction, then work back in the other direction, creating a solid line.

I opted to accentuate my mountains and little house shape. For added variety, I split the fibers in my embroidery thread to create various line weights.

6

Saturating your brush with water, dip it into the paint of your choosing and create a flat wash filling in all the white space surrounding the circle. Does the color symbolize a part of the story you are sharing with this image?

This is a wonderful process for revisiting old neighborhoods or commemorating special trips. It takes the idea of mandalas as cosmic maps in a whole new direction.

TRACY VERDUGO

I am a big fan of Tracy Verdugo. I have followed her online for years and love her book *Paint Mojo*. I invited her to contribute to this section, we had some conversations by e-mail and ultimately that is exactly how her contribution unfolded. This is the story itself, the actual e-mail per her request.
My favorite inquiry over the past few years has been "What if it was easy?" So when she suggested we just use the actual e-mail, my response was "Absolutely, yes!"
TRACYVERDUGO.COM

All That Cannot be Contained

a sketchy placement of marks
random yet intentional
out of which a tendril appears
looped, bold and reaching
becoming
a solid block out for other ideas
that will not bear fruit this time
a self-commissioned treasure
which shouts
"Look at me! Look at me!"
i am this lush green foliage
i am this foot taking one step
in one moment and direction
i am this doorway with
wordless Mystery beyond
the way forward, backwards, sideways
the light piercing the darkness
the endless intersecting paradigms
of perception
let me tie a knot to remember
this warm verdant embrace
this tender shoot of endless intent
let me navigate each intricate twist
each delicate bloom
while Passion flowers

out of what was
once
a sketchy placement of marks.

The Story Unfolds

Actual narrative from our e-mail:

I just sat down to work on the story slice for the painting I am contributing and was going to write about a couple of events in our life which seemed overwhelmingly bad at the time but, looking back have led us directly to the beautiful place we are now.

These kinds of quantum connective moments, the endless micro decisions that move us through, allow us to perceive and respond to what life hands us via conscious or unconscious choice (each time propelling us forward in an ever-expanding, thought impulse-directed flow) are endlessly fascinating to me.

Indeed most of my work and process revolves around this fascination.

Anyway, before I started writing I decided to do a warm-up exercise which I have my students do in class. It involves a small inspi-

ration bundle made of torn images and text selected from random and unrelated sources.

While holding space in my mind for the theme or topic I would like to explore, I look at each image and allow a subconscious thought stream to give me a word, several words or a sentence or two in response.

Continuing in this way with each image a poem begins to form, which always addresses my current state of mind or a situation I am dealing with.

In this case the poem which arrived in my warm-up exercise described this wobbly circle piece perfectly and now I do believe that the warm-up exercise itself and this little unplanned narrative I am sharing with you in this e-mail have BECOME the story slice. Hope this makes sense!

Considering my fondness for going outside the rules, wobbly circles and all, perhaps a poem from me rather than prose, is quite apt.

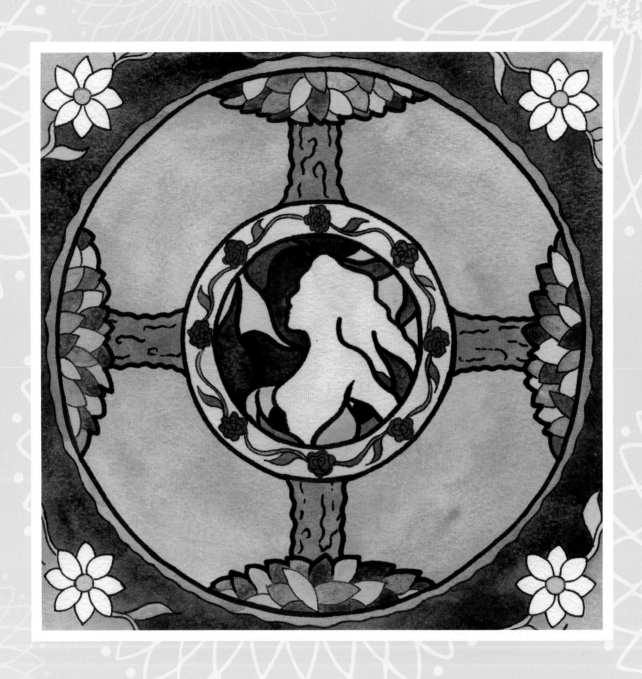

66 *Knowing yourself is the beginning of all wisdom.* —ARISTOTLE

Circles for Self-Discovery

Carl Jung believed that mandalas (circle drawings) are representations of the unconscious self, and to draw or paint them allows one to tap into this and work toward "wholeness in personality." If you are willing to entertain this theory, creating within the circle seems the ideal vessel for self-discovery.

The introduction of this book mentioned that the circle-making processes we explore are about so much more than making a pretty picture. These exercises are about working toward fuller self-expression. They are about your experiences and journey, not solely the visual outcome of the canvas.

You may find it challenging to consciously turn inward for the sake of exploration. There are certainly jewels to be found, but often one has to move around a lot of debris in their pursuit. Please know: You are safe to express your truths in this creative process.

Self-Portrait

Carl Jung believed mandalas are a representation of one's unconscious. I believe all circle creations or mandalas are in some way a portrait of self. Given that one of the main benefits of this process is self-connection, it is time to dive right in and create a self-portrait. In this playful exercise you will create an impression or representation of yourself on top of a circular image transfer of yourself.

Find a favorite photo of yourself, resize and print it to fit your panel, and get ready to have some mixed-media fun!

What You Need

acrylic matte medium

acrylic paint in your favorite color

compass

drop of oil (I used olive oil.)

foam brush, 1" (25mm)

inkjet or laser photocopy of your portrait sized to fit on the panel

magazine pages with images to fill up the space surrounding your portrait

old credit card

opaque paint pens (Posca)

paintbrush

paper towel

pencil

ruler

scissors

unfinished balsa panel, square

water

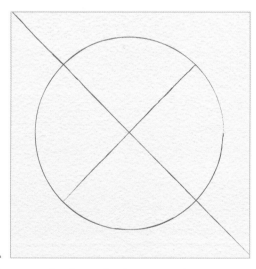

1

Using your ruler, draw a line from corner to corner on your panel. Repeat on the opposite corners to mark the center. Anchor your compass in the center and create a circle. I sized mine to 3½" (9cm). Trace the same sized circle on the portrait printout and cut it out.

2

Dip your foam brush into the matte medium and paint a thin, even layer on your panel. Working quickly, place your portrait facedown in the circle you traced. Fill the remaining open spaces on the canvas by placing the magazine pages facedown as well. Smooth the papers completely onto the matte medium and panel by rubbing your fingers or old credit card back and forth firmly against them. Allow the piece to dry for several hours.

3

Fill your container with water, dip and wet your fingers and begin rubbing the surface of your panel. The paper of the images you glued down will begin to soften and lift up. Because the matte medium is completely dry the image will remain. You are creating an image transfer. Continue to gently rub back and forth on the surface, constantly wetting your fingers. The pulp of the paper will ball up and can be wiped away, revealing the images that have transferred to the panel itself. Allow the surface to dry and if there are opaque white areas, continue rubbing a bit more. Some ink may lift in the rubbing process; don't worry about it as it adds to the character of the piece. Continue the drying and rubbing process until no white opaque areas appear when the surface is dry.

4

Wash your hands to remove any pulp or medium from them. Apply a drop of oil to them and rub it across the surface of your panel. This intensifies the images you have just transferred. After you have rubbed the drop into the entire image, take a paper towel and remove any excess oil by wiping down the surface.

5

Use the paint pens to embellish the image. Draw anything that comes to mind and know that it is appropriate. For some reason I was called to turn my background into a dense jungle and add a crown to my head. Have fun with it!

6

Paint the edges of your panel and place this little artwork somewhere special to remind yourself of the fun creative one who lives inside.

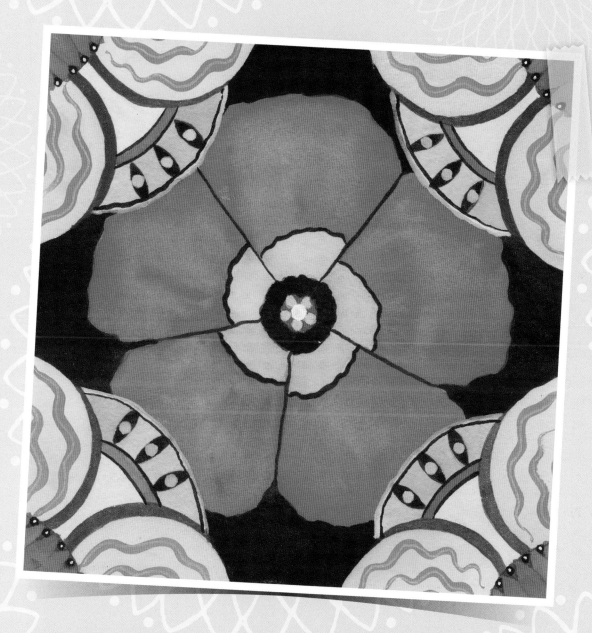

Just as creating within the circle can be used as a means of self-discovery or for the creation of self-portraits, circles can also be drawn or painted in honor of an individual.

This hibiscus mandala is just that, a portrait of my mom and her many qualities.

At the center a hibiscus, symbolic of perseverance, and with the color red—an association with passion. Marigolds make up the corners, symbolic in this case of resilience. Yellow is present, symbolizing sunshine (and also reminding me of a pretty hip yellow suit Mom once had from Casual Corner years ago).

The mandala as a whole is always representative of the universe. If I'm the one painting, my universe. My mom, this bright, bold passionate red flower pictured above, has always been a central figure in it.

Expressing What's Inside

YOU JUST intentionally created a self-portrait starting with an actual photo of yourself cut out into a circle. You will find as you continue to create within the circle each one really is a reflection of you, even if not based on a literal image.

When I first began the process of creating story circles on a daily basis, I was focused on painting them to celebrate other people or commemorate moments. I was aware of Jung's theories on mandala creation but didn't think they applied to me. Despite this, one evening I found I had inadvertently created a depiction of myself.

After realizing I was on the verge of losing my cool as a result of multiple stressors, I started a mandala. I had already done some mandala work in the morning, but my daughter asked if we could paint. It seemed like forever since she had made such a request, so I said, "Absolutely!" Pale pink gerber daisies sitting on the table provided instant inspiration!

I sat. I measured. I drafted. I took my straightedge and with each orderly line drawn, a little relief washed over me. With each perfect petal a softening of the shoulders. With each additional layer, a little less high-strung, a little more grounded. I stopped and looked at a few of the other mandalas I had been working on from earlier in the week. Each was much tighter in appearance and more intricate than most of my work. A lot more controlled.

As I looked at them, I realized I was exercising these feeling of being out of control, right there in my circles—a huge aha!

I drew the circle based on the daisies. I painted it. I retouched it. I knew I could continue to improve upon it again and again. That evening I realized I had unintentionally created a self-portrait of sorts. That evening I realized all of the circles I paint really are a personal reflection.

As you review the circles you have created thus far, can you identify how they relate to your own experience in the world? What do the symbols and stories you choose to express in the mandala format have to teach you?

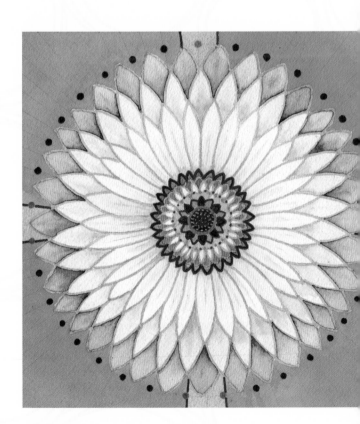

Symbol Exploration: Mandorla

A MANDORLA is a sacred symbol created by two circles; it is the space of the overlap.

This almond-shaped ancient symbol has an extensive history. Believed to originally have been associated with the yoni or female genitalia, it is symbolic of fertility.

Christianity later adopted the mandorla and began using it as an aureola or arch-like framework for religious images. It redefined the mandorla as the arcs of two circles, left for female matter and right for male spirit.

Jung believed that mandorlas signified the clash of opposites and the space where they meet: male and female archetypes, conscious and unconscious self.

I like to view it as the space between here and there. I like to think of the mandorla as the sacred space in between.

Take a moment to consider the spaces of overlap or transition in your life. How do you feel about them?

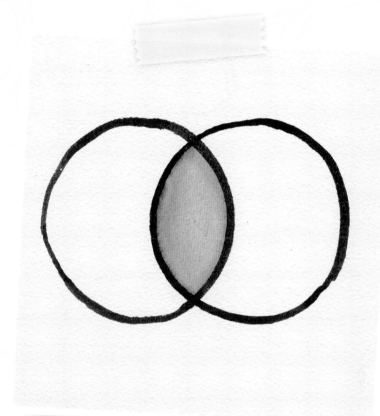

Personal Mandorla

The mandorla is the overlap between two circles. Two spaces. In this exercise we explore where you currently are and where you might like to one day be. What your current story is versus what your ideal story is. We explore this versus that, but more importantly, we discuss where these two seemingly separate realities overlap, where they integrate.

Prepare to identify through art-making your own story, which you can begin to step into today.

1

Using a ruler, measure out and make a small mark at the halfway point on four sides of a square sheet of paper. Anchor your compass point on one halfway point and open your compass so your pencil is on the one above it. Make an arc mark on the page. Repeat the process on the opposite side of the page, creating a mandorla or almond shape.

2

Using permanent ink, paint one side of the mandorla black. Using a black marker, mark out four lines on the opposite white side, delineating sections.

What You Need

black ink, permanent (Higgins: Black Eternal)
cold-pressed watercolor paper, square
compass
pencil
permanent black maker, ultra-fine point
ruler
water
watercolor paints of your choice
watercolor brush: size 08 (Royal Aqualon)
white gel pen (Sakura Gelly Roll)

3

Select a color that appeals to you and paint or color the mandorla shape. I used Opera by Holbein.

4

Using a white gel pen, mirror the four black lines you created on the white side of the mandorla onto the black side of the mandorla.

5

Look at the page and consider how the white side represents the present and four areas of your life you want to bring focus to right now. The colored mandorla section represents the near future. The black side represents the unknown future, with the same four areas of your life represented. Choose one section on the white side, and using a black marker, begin making marks that symbolize what currently exists in that area. Consider how you might like this to shift and move to the black area opposite, and using a white pen, make marks symbolically illustrating how you would like that area to operate in the future.

6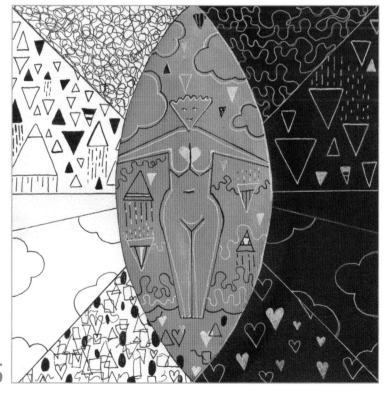

Repeat the same process in the remaining three sections. If you find you would like to focus on more than four sections, feel free to divide them further as I did.

WHITNEY FREYA

I see Whitney Freya as a creative kindred working with painting and sacred symbols to find her way through the world while also guiding others to do the same. Enjoy this piece she provided as another take on mandalas as tools for self-discovery.

WHITNEYFREYA.COM

"*You radiate...what do you want to radiate?* —YELLOW TARA

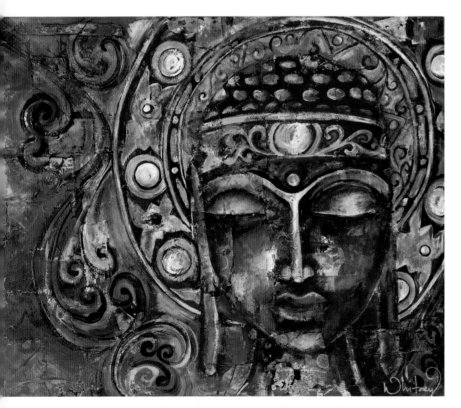

Every time I see this painting it reminds me of the opportunity we each have to radiate divine energy. I believe we each have this same "mandala crown" that we can manifest into our lives as love and light when we remember that we are so much more than the being contained within our physical bodies.

Mandalas as a Means to Access Personal Power

My own mantra, and my personal message for the world, is "Life is the canvas of your Soul." I connect to this truth in my personal painting practice, especially when I am feeling puny, stuck, scared or worried. By simply painting, I engage with my infinite, intuitive, creative self—my Soul. Then, what I paint creates different energy and sends a different message to my Soul. Symbols and images become messages to my BIG me and they help my little me detach from lower vibration feelings.

I often use mandala as a *yantra* (an image used in meditation to raise your vibration) and imagine all the hectic details of life, the demands and to-do lists swirling randomly all around me, as pieces of light and color. In

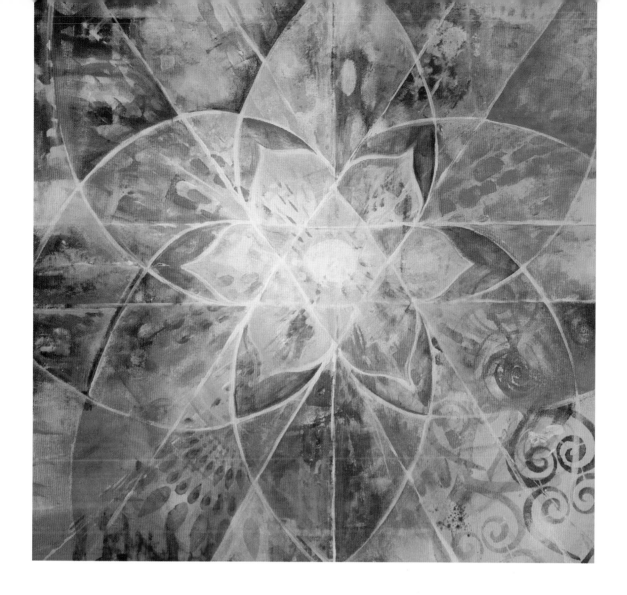

my mind, I imagine these colors spiraling and arranging themselves into a beautiful design—a mandala. I choose to see myriad of colors in my life working together to create a divine design. Next, I see that this mandala of details and schedules is simply the closest one to me and the smallest. So I send my awareness up to the next "mandala," which is comprised of emotions and feelings and memories. Then, up I go to the mandala that encompasses whole universes and I allow it to expand my awareness until the details and daily frustrations feel so remotely miniscule. Finally, the last mandala, encompassing the all that is all, is simply love. Yes!

When I first was given these images to use in meditation, I understood that I could choose in each moment which "mandala" I was plugged into. Each mandala I paint reminds me of the magical design that is orchestrating my life. I allow the mandala to create within me feelings of perfection, order, unity, wholeness and magic. My wish for you is that this Yellow Tara reminds you of how powerful you are and how you can radiate your magic to your world around you.

"

Daring to set boundaries is about having the courage to love ourselves, even when we risk disappointing others. — BRENÉ BROWN

The Circle as a Boundary

As earlier defined, a circle is a set of points a fixed distance from a center point, a closed shape. Everyday use of the word *circle* refers to the entire figure, both the boundary and the interior. Technically defined, however, *circle* is simply the boundary of the shape, a dividing line between two separate spaces.

The circle as boundary has played an important role throughout history: the priest marking a circle in the sand; Wiccan traditions casting circles of protection before performing ceremonies; culture after culture creating round structures for both living and ceremony; and hogans, teepees and kivas made by Native Americans. Expanding one's view to global areas and traditions, we can look to the stupas of Southeast Asia and the round churches of Europe. Circular structures or boundaries have been used across time, culture and geographies to create consecrated space.

Your Sacred Space

Circle as protection, circle as consecrated space. The time spent making personal mandalas creates exactly that in your busy life. It is a claiming of time or space to engage in an act that feeds your creative urge or need for self-exploration.

During this exercise we will focus on symbolically creating the same sacred space within our own lives.

What You Need

cold-pressed watercolor paper, square
opaque paint pens (Posca)
pencil
water
watercolor brush
watercolor paint

1 Draw your circle centered on a page. Try it freehand with no rulers or compass this time. Don't worry if it isn't perfect. This circle symbolizes our own sacred quiet space.

2

Wet your brush and lay a clear wash across the entire circle. Using the same brush, dip it into your watercolor paint (I used Cerulean Blue). Load the brush full of paint, then pull your brush across the top of your wet circle. Without adding any additional paint, make another stroke across your circle, just barely touching the edge of the previous stroke. Continue this process moving down the shape, creating a gradient wash.

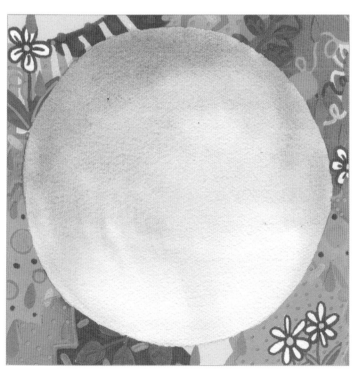

3

Once your wash in the circle has dried, begin filling in the surrounding space using your Posca pens. Create little marks and shapes as symbols representing things in your daily life. This space is to illustrate everything that can distract you from the quiet sacred space within yourself. You will see I drew a lot of beautiful things as well as the ugly or mundane. Keep in mind, it is often the attractive distractions that are hardest to resist. Fill the entire space, the only remaining white spaces being those representing white shapes likes the petals on my flowers.

A Vessel Can Only Hold So Much

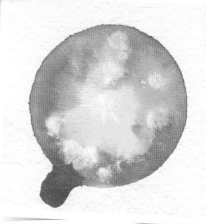

EARLIER IN this book I shared the story about my return to creative expression and finding self-connection through working with the circle. How the moment I began to sit down with my compass, find my center and mark out this beautiful shape on a consistent basis, everything began to settle down.

Making the circles slowed the swirling of what sometimes felt like the chaos of daily life surrounding me. I have since been repeatedly amazed by the lessons I receive from the circle as mandala and as a means for expression. I am also full of wonder by the things that each iteration of teaching Story Circles points out to me in other ways.

When I first began sharing this process I started an online class and would send daily video lessons in between caring for my two young children, maintaining an outside job and attempting to maintain a household.

In one early round of class it all got to be too much. We had a ten-day stretch of illness in our house. It seemed we were smacked by one malady then the next. The kids, my husband and I had all been down for the count. One night, which was when I normally prepped the final e-mail and lesson for the following day, the perfect storm occurred. Steve was

traveling for work, I was still a little sick with a stomach bug and both of my kids were suddenly and simultaneously struck by it. I couldn't complete the lesson or e-mail to send and I was horrified.

The following morning I sat down to send the e-mail and I kept thinking, *I'm late. I'm not even sure what to write about. How do I recover?* Later in the day I thought to myself, *Now this is ridiculous, send the lesson, what do I say?* Finally by the afternoon I was asking myself, *What is the lesson here? I am sure there are many*

At last it came to me. I had to discuss boundary. I had to reexamine my own boundaries and set new, more realistic ones. I had to reexamine the circle as vessel. I had to talk about it as a container, but one that exists in relationship to the world around it. One that can function as a boundary to create our own consecrated space.

In the previous exercise we explored the circle in exactly this context: a line of division between quiet and chaos. Conversely it can be explored as a vessel or boundary capable of holding a finite amount.

When you consider these possibilities, circle as finite vessel (we can only hold so much) and circle as boundary, what comes up?

Symbol Exploration: Chalice

CUP OR CHALICE symbolism is complex and deep and begins with female or womb associations similar to the circle. It can later be found in various stories and traditions including pagan, Christian and Jewish.

To drink from a special chalice was said to do things like renew one's youth, heal one's illness, provide all the food a person could ever need or even legally bind a couple in marriage.

To hydrate is to survive, and I attach a lot of individual symbolism to the cup. I have crafted several small drinking vessels for myself out of clay, and each morning I spend a moment or two sipping water from one, visualizing what exactly I want to "fill" myself with for the day—be it calm, creativity, tenacity or anything else that comes to mind.

Do you have a special cup you could drink from with intention? What would you drink?

Your Magical Chalice

The cup nourishes. It holds its nourishment and simultaneously fills from it, you the drinker. In this exercise we will spend some time considering what exactly we would want in our magical chalice and paint it.

What You Need

cold-pressed watercolor paper, square

compass

pencil

permanent markers: black in various width sizes

ruler

tracing paper

water

watercolor brushes

watercolor paints: primary colors (I used Winsor & Newton's Cadmium Yellow Deep, Cadmium Red and Cerulean Blue.)

1

Using your ruler and your pencil, mark out the center of your page by drawing two diagonal lines, one connecting each opposing corner. Measure out the halfway points of the top and bottom of the page and draw a vertical line connecting these points as well. Measure 1" (3cm) from the bottom of the page on this line and draw a perpendicular line. Measure 1½" (4cm) down from the top and draw a perpendicular line. Anchor your compass point to the center and draft your circle, filling most of the page.

2 Draw out half of your chalice. Follow steps 3–5 to make your own graphite paper and see how to copy this half to the opposite side, creating a perfectly symmetrical vessel.

3 Lay a piece of tracing paper over the image half you have completed drawing. Using a pencil, trace the parts of the image you want to mirror. Make sure to trace any midline as it is an important point of reference.

4 Flip the tracing paper drawing-side down to the opposite side of your watercolor paper. Line up the midline, top and bottom lines and begin rubbing the drawing from the back of the tracing paper using the tip of your pencil.

5 Remove the tracing paper to review the transfer. Erase any smudges. Voilá, you have now created a symmetrical image.

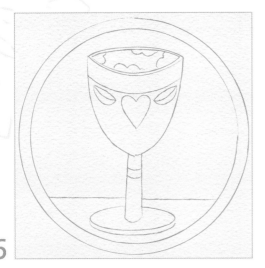

6 Complete the drawing of your chalice. Are there any symbols you would like to add to your cup? In what environment does it exist? What if anything will you paint on the inside?

7 Dip your watercolor brush in water. Beginning with your lightest color, fill your watercolor brush with paint and begin filling in every section of your picture that will be that color. Allow it to dry completely.

8 Repeat the process of painting in each section color by color, allowing each one to dry completely before continuing on to the next. Waiting for each color to dry completely keeps the colors from bleeding out into one another.

9 Using black markers of various line widths, outline each element in the drawing. Use a thicker line on larger elements and a thinner line on smaller.

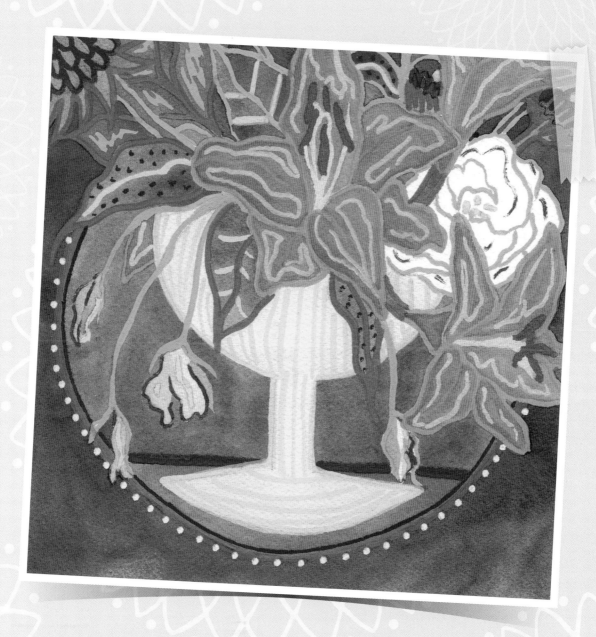

What is my chalice composed of? What does it contain?

This piece, also created with watercolor and marker, is comprised of a golden vessel and various flowers. The vessel in addition to being symbolic of the chalice itself is made of gold. Gold signifies illumination, wisdom and wealth. The identifiable flowers are tiger lilies and strawflowers. The lilies stand for passion and abundance while the purple strawflowers stand for constant remembrance and agreements.

Even the colors in this piece bring meaning. The orange symbolizes creativity and stimulation while the blue signifies loyalty, faith and intelligence.

DEB TAYLOR

Deb Taylor likes to play with circles in various mediums. Her favorite is
needle and thread. Below she shares how the circle format soothes.

DIDDEBDOIT.BLOGSPOT.COM

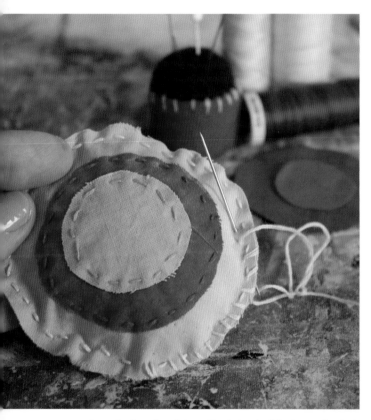

As a mixed-media artist wanting to touch all the types of materials from paint to metal to clay to fabric, I always return to needle and thread. It is my comfort zone. I've been sewing since I can remember. Clothing, art dolls, quilts and fabric journals. Bright colors are my palette. And when I need to be contained with a simple project to keep my hands busy, the circle is my friend. It is a small boundary that keeps me focused.

Circle as Soothing

I layer and stitch and create surfaces that are pleasing to my eye. Then when I have a pile of happy circles, I might appliqué one onto a little fabric gift bag. I sew them onto art journal covers. I sew them onto paper and send postcards in the mail. I use them to embellish larger pieces such as art quilts and tote bags.

For me, the circle lends itself to be an achievable, less daunting art project rather than a large canvas painting or finished quilt. I travel with little circles of fabrics, needle and thread. I get into a Zen-like method of going round and round. I prefer the soft curves of fabric, rather than the hard lines of watercolor paper, when I am art journaling. I can hold my little masterpiece in my hand and weave and stitch my secret story. The bits of fabric and fibers each represent a memory and when I am finished, my circle is holding all of them together, in sacred space.

I am a very hyperactive woman with so many different interests, always moving in so many directions and spinning a lot of plates. The circle serves as a "container" for me. I can reign myself into the small familiar space and create little masterpieces.

I have the urgency and obsession to create and make art every single day. I am my happiest when I am creating something with my hands . . . maybe cooking a fabulous

dinner. Photographing an amazing sunset. Slow mending a tattered pair of old jeans. At the end of my day, I look back on how I have nurtured my family with good foods. I share my beautiful and inspiring photographs on social media. I witness the joy in my son's face when I return his tattered pair of shorts with all my hand-stitched love and visible repair. For me this is necessary. To share my art with the people I love. Nothing you can buy at the mall can express the love I have for my family and friends. I recall a quote from a woman who once said, "When I give you a gift I made with my hands, I give you a piece of my heart."

"The more faithfully you listen to the voice within you, the better you will hear what is sounding outside. — DAG HAMMARSKJÖLD

Finding Center

The literal meaning of *center* is middle. If one references da Vinci's Vitruvian Man within the circle, the geometric middle of man falls at the navel, the belly. When someone says find your center, are they really asking you to touch your belly button?

More often than not the request is an invitation to drop in and on some level connect to yourself. Perhaps to take a few deep breaths. Maybe to slow, to still, to enter the quiet space of knowing that resides within each of us. Often if not always to access your intuition.

Perhaps you know where your center resides, perhaps you don't. Breathe in deeply and take note where the breath halts. Lay your hands upon your body; where do they naturally fall? When you allow the world to fall quiet outside you, close your eyes and allow yourself to feel fully connected to the sacred voice within. Where does it reside?

This is your center.

To Measure and Mark as Meditation

A circle is a shape composed of points in a single plane that are all at an equal distance from the center point and connected with a line. Without the center you have no circle.

This center point, sometimes referred to as a *bindu*, is really where we must start. This single point is metaphorically the source for all creation. It is the point around which we create our circle. Around which we can capture or build our stories. It signifies the center or sacred seed within ourself.

In this exercise, spend some time measuring and drafting. As you find center on the page, you might find the process also brings you closer to finding center within yourself.

What You Need

acrylic artists' inks: one dark color and white (I used Daler-Rowney's Marine Blue.)

compass

markers: four colors

pencil

ruler

water

watercolor brush, size 6 round

watercolor or mixed-media paper, square

1

Locate the center point on one edge of your paper (My page was 7⅞" (20cm) so my center point was at 3¹⁵⁄₁₆" (10cm). From this point measure out and mark 1" (3cm) increments in each direction. You will have a total of seven marks. Repeat this process on each edge.

Inhale as you measure, exhale as you mark.

2

Choose one of your markers and using your ruler, connect the dots across from one another closest to each edge of the paper. You will end up with four lines intersecting at the corners, forming a square.

Check in with your body, relax your shoulders.

3

Working your way toward your center point, repeat this process with the corresponding dots and remaining markers.

The first three sets of lines will create nesting squares. The final set of lines, those used to connect your center sets of dots, will create only two lines. As you mark the second of these lines, you have located your physical center on the page.

Take a deep breath. See if you can locate the center in your body as well.

Using your ruler and coordinating markers, connect the points diagonal from one another for each set of points.

As each line passes through center, feel yourself move closer and closer to yours internally.

4

Anchor your compass at the center point and open it to create a circle that fills most of the page (I set a radius of 3½" [9cm]) . Contract the compass to create a smaller circle at center (I set a radius of ¾" [2cm]).

Let the area outside of the larger circle represent the outside world, the large circle your body and the space inside the smaller one your sacred internal space.

5

Wet your brush with water and use the dark ink to create a flat wash of color surrounding the large circle. Using fresh water, repeat the process using the white ink in the center circle.

Take a moment to see if you can feel the same calm and spaciousness within the white circle inside yourself.

6

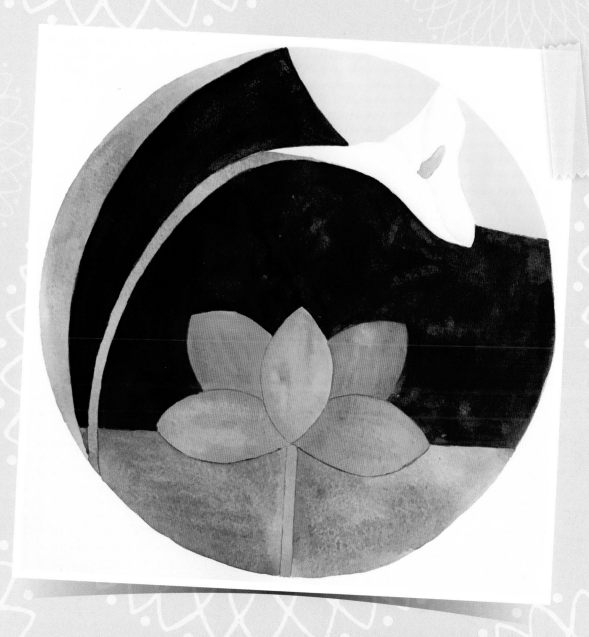

Making any mandala will likely lead you to center, geometric and measured or not. In this circle I chose to focus on two important symbols for me: a bold palette and simple lines, all things that remind me of the sacred space within.

Across the top, the white calla lily symbolizes faith, purity and rebirth; we may always begin again. Shaped like a trumpet, it also signifies triumph as it rises above. The lotus beneath is a canonical symbol of enlightenment or rising above. Beginning its life in the muck and the mud, this bloom rises above. It is a symbol of creation and awakening.

What Do You Mean 'Find My Center'?

I CAN'T tell you in the early days of my yoga practice how many times an instructor would cue "find your center," offering little to no additional direction. What was the ambiguous place they called "center" and how exactly was I supposed to find it? Just the instruction made me want to drop into corpse pose in surrender.

One class led to another and slowly I realized what they meant. I also started to understand why there was little to no direction on how to locate it. It is an individual journey. Over time we each develop our own process to access our "center," and its location can change from day to day.

I found the center to be the quiet, calm space within. The space inside where things process slowly enough that I can actually bear witness to them. The space inside where I can receive direction and actually hear it. The space I knew so well after years of art-making even if I didn't have a name for it.

The center is where my truths reside (I suspect it is where your truths reside, too). The center is where I am most myself. The more time I spend here the more I realize it is from here that I must also radiate out. It is from here that we all must.

You, too, may find that mark-making inevitably relaxes your jaw. Big brushstrokes on a blank canvas can deepen your breath. Symmetry can soften your shoulders. Each of these are signals of moving closer and closer to that sweet space inside.

Drawing a diagonal line from corner to corner, then anchoring my compass at the cross point, breathing as I work, brings me there every time.

Do you find the same experience? What ways do you find your center?

Symbol Exploration: Sun Sign

CIRCLE IN A DOT, the sun sign. As earlier stated, a circle is defined as a set of points at a fixed distance from a center point connected by a line. In many two-dimensional circles the internal space is completely empty or totally solid, and the center point is not visible. In the sun sign the center point is visible and extremely important!

"The Sun Sign according to the oldest symbolism, the circle enclosing a dot represented the primal womb containing the spark of creation."
—*The Woman's Dictionary of Symbols and Sacred Objects*.

The center point a sacred spark, a *bindu*, the point from which all else in the universe emanates.

The center is the source.

If you are the circle and your center is the sacred spark of creation, what do you want to radiate from it?

What Do You Radiate?

In this exercise, you will locate your center and while cutting and pasting, consider exactly what and how you want to shine out to the world around you.

A universal symbol associated with shining or radiating, the sun emits light and warmth; it supports life as we know it. This mixed-media collage exercise uses the sun as inspiration and a framework.

What You Need

8" x 8" (20cm x 20cm) wood panel

acrylic matte medium

acrylic paints: two warm colors (I used Liquitex's Cadmium Orange and Raw Sienna.)

collage papers, assortment

compass

foam brush

metallic permanent pen (I used a gold Sharpie.)

paint pen: white (Posca)

pencil

scissors

small cup (optional)

straightedge

water

1

Place a pea-sized amount of each paint color on your board and using a slightly damp foam brush, mix the colors and spread them across the board, creating an even coat of color. Let the paint dry.

Using a straightedge, draw a short diagonal line from corner to corner, creating an X and identifying the center. Take a moment to identify and mark the center point with a noticeable dot. This is the *bindu*, the sacred seed. Anchor your compass and draw a circle with a radius around 3 " (8cm). You have just created a sun sign.

Meditate on this spot for a moment and think about what exactly it is you want to radiate out to the world. If it appeals to you, write a word or two in the circle, summing it up. Don't be shy; this word will be concealed by the sun-inspired collage you are about to create.

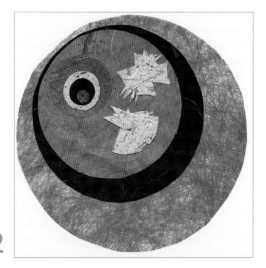

2

Using your compass and collage papers, measure out circles of varying sizes. Cut out some decorative ray- like or triangular shapes as well. Keep contrast in mind as you choose the papers for each layer: big against small, light against dark, shiny against matte. Prepare all of your papers before you are ready to glue by laying them out on a sheet of paper to determine your finished composition. Place another page on top of this and turn it over so the bottom layers are on top.

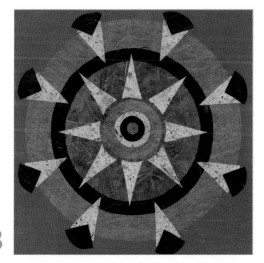

3

Pour matte medium into a small cup or onto a scrap of paper and coat the tip of your foam brush. Create a thin even layer of medium on your board, then center and smooth your largest circle onto the surface. Smooth the piece from the center out. Working from top to bottom, alternate between adhesive layer, paper layer until placing your topmost pieces.

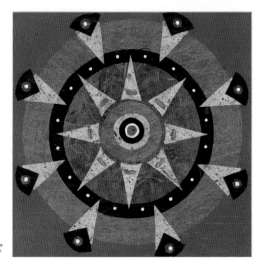

4

Once the matte medium is completely dry, take your metallic pen and add some details to various areas of the sun-inspired mandala. Repeat the process with your white paint pen as well.

KELLY BARTON

Kelly Barton and I once discussed mandalas, and she shared that she loves the process of making them, of sharing them. She loves the process of guiding people in the construction, working from the outside in, ultimately allowing the maker to access the juicy center.

KELLYBARTON.COM

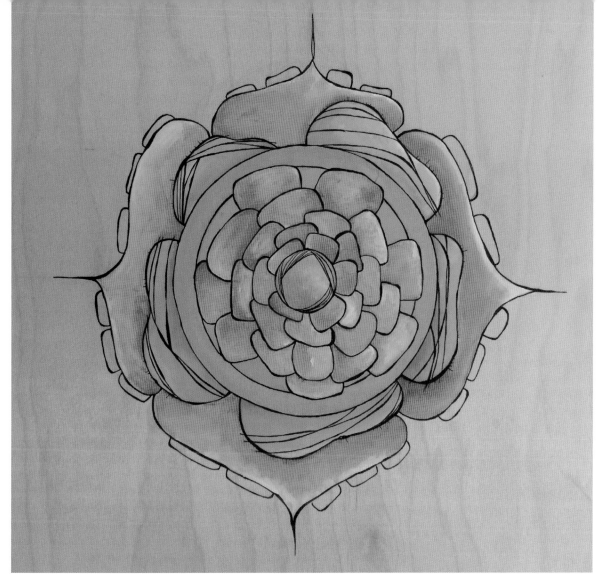

Pretty little blossom — life needs to be nurtured. Tended to. Each layer sprinkled with light. It is how we grow. The blossom growing out of the center shares that light.

Finding Center

Life can be greeted each day with scurry and stress. It can suddenly turn on a moment's notice, tumbling over uncomfortable instances. Finding center is one of those bits in life we tend to let slip through our fingers.

I have always been drawn to the circle. As kids at family camp, we sang Harry Chapin's "Circle" around the campfire. I was taken by the words. The common mirror of life before us. The same road taken because of old stories and lessons.

Creating mandalas is where my heart can find a happy rhythm. My mind gets lost in the layers and the meditative process of the round, slowing down from all the junk and business that life can throw at us.

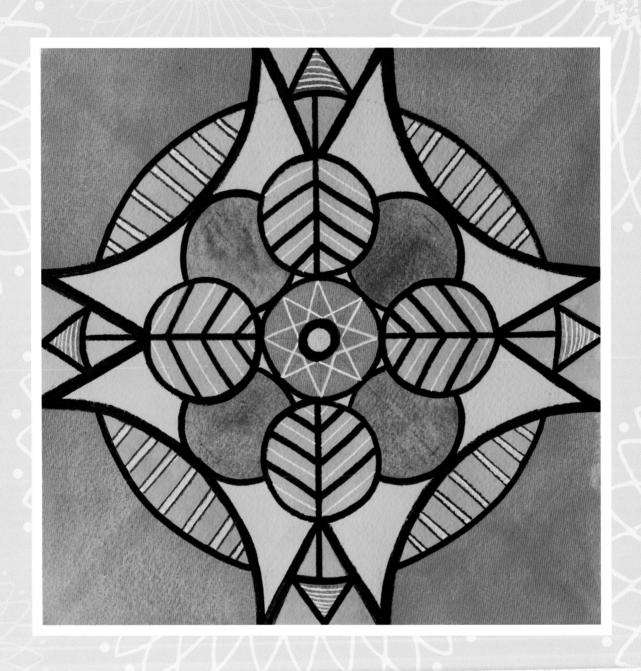

66 *Your passion is your internal compass that will guide you from where you are towards where you want to go.* — JULIE CONNOR

The Circle as True North

Compass: An instrument that always points the way to true north.

Compass: An instrument for drawing circles, usually with two arms and a movable joint.

One word with vastly different definitions, which when it comes to creating a true north mandala, are closely connected to one another. You use a compass to draft a circle to create a compass to identify your true north.

The quote at this chapter's opener states that passion drives one's internal compass. At times it certainly can. However, values can be an even stronger driving force. Passion can sometimes dim or even burn out. Values are what one holds important in her life. Not quite as exciting or sexy as passion but far less susceptible to time or change of interests. Values can serve as your North, South, East and West.

Similar to *compass*, *values* has varying definitions that are applicable to this section.

Values: That which one holds important in her life; a person's principles.

Values: The relative degrees of darkness or lightness of a color.

Values, an important component in building a foundation for the way we live our lives. Values, an important component in the art-making process.

This exploration of compasses and values will help you clearly identify your true north.

Values-Based Compass

Identifying what's important to you is a powerful process. Your values provide a point you can return to again and again when making important decisions. This knowledge can always point to true north.

Take a few moments to identify five areas you always consider as you make important decisions.

Pull out an influential book or article that relates to your values and photocopy a couple of pages.

Now it's time to create your mixed-media values-based compass.

What You Need

black ink and/or marker
compass
glue stick
pencil
photocopies of words from an important book that has influenced you
ruler
scissors
text-weight paper, 2 pieces
water
watercolor brush, size 06

1

Create a square sheet out of your paper. Using your ruler, draft diagonal lines from corner to corner. After identifying your center point, draw horizontal and vertical lines through the center point. Anchor your compass at the center point and create three circles with radii of ¾", 2" and 4¼" (2cm, 5cm, 11cm). Repeat this process on the second sheet.

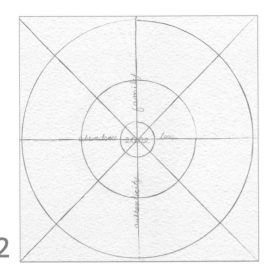

2

Recall the five things you identified before beginning that are important to you. With a black marker, write out one item on the center point of the inner circle and on the horizontal and vertical lines you have drafted.

On my center circle I wrote my guiding principle. On each of the four central lines I wrote an important value. Repeat this process on the second page.

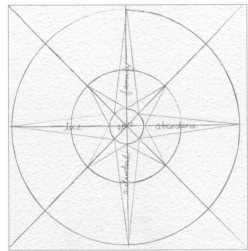

3

Follow the lines you drafted on your sheet as a guide to draw out a north star compass emblem. (Draw a line from the center point on each paper edge to the point the adjacent diagonal lines intersect with the inner circle. Do this in each direction. Draw a line from each point of intersection between the diagonal lines and middle circle to the points where the horizontal and vertical lines intersect the inner circle.) Repeat this process on the second page.

4

Prepare one of the sheets as a template by cutting it into five pieces. The pieces consist of the center circle—with four short points radiating from it—and the four longer points created around the lines you wrote your items of importance on. Use these templates to cut identically shaped pieces out of your photocopied text sheets. Keep the center pattern piece intact and set it aside for a step to come.

5

Dip your brush slightly into black ink and paint the interior space of the two inner circles. Rinse the brush in a dish of water and reserve the muddied water for a later step.

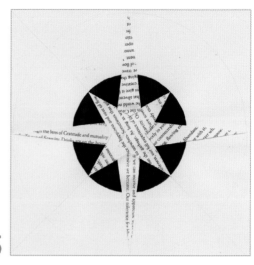

6

Coat the back of each photocopied text piece with a glue stick and place it on the corresponding area of the sheet with the black circle. Smooth each piece, securing it completely to the paper.

7

Cut the circle portion out of your center pattern piece. I cut slightly larger than the drawn circle to cover intersecting points on the finished work. Use this pattern to create an identical piece out of the photocopied text.

8

Use the water you rinsed your inky brush in earlier and paint the central circle piece. It will tint it light gray, creating value contrast. Glue it to the center of your piece.

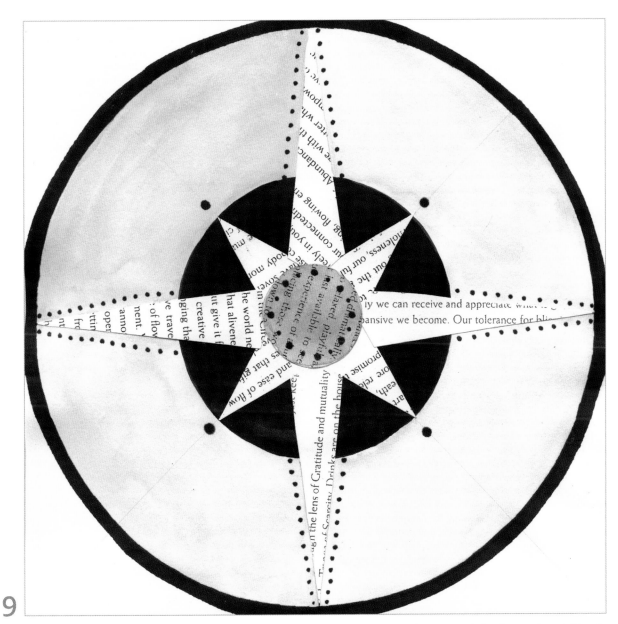

9

Use your brush and black ink or Sharpie marker to create a thick black line along the exterior circle of your piece. Add various small details along the compass shape you just created to add visual interest.

Of Course I Know My Values!

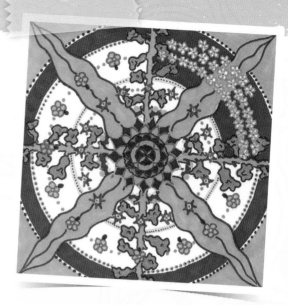

A FEW YEARS AGO I was sitting in a large room as part of a business mastermind group. I was one of twenty-one people, all of us there for different reasons. At the time I believed mine was to regroup, refocus, reinvigorate what had been my business for the previous thirteen years.

Imagine my surprise when Jonathan Fields, our leader, stood up and asked if we knew our values; if we could specifically name them. At first I half-smiled, muttered to myself, *Of course I know my values . . .* then stopped. I discovered I couldn't specifically name any of them.

As a group we started shouting out what could be considered various values, ultimately identified those that resonated with us, then were given a few minutes to name those we could truly own. Those that guided us in our decision-making process, those that if not currently serving as a north star for us should be.

First I drilled down to seven, too many; then to five, too many. I ultimately hit upon three that changed everything for me. It illuminated for me why the things that I deemed successful in my life were working. It also made clear to me why so many things were not.

Since this experience I regularly check in with my values. They have recently shifted as have I. It is a powerful experience to be in conversation with myself about what really

This Story Circle was created on a weekend spent with Jonathan Fields and our mastermind group. We went for a hike. I took little snippets of different flowers as we walked—sage and bluebells, little delicate pink blooms, big purple pokey ones and many more. This circle is a token to remember this magical weekend. Elements it contains: some of the plants from our hike, alignment and symmetry, bold relationships between objects, some unexpected color that somehow works just right, white space—"unfinished" paper representing the possibility of what can come in and fill it. And finally, in the upper right corner, the spotlight of thirty-three little blossoms. These represent the thirty-three people who were part of the weekend—the tribe, our guides, our coaches, their families. Just like these little flowers grew in tight clusters creating blankets of beauty on the vistas we hiked, we had banded together this past weekend and for several months prior to create something magnificent.

matters as I make daily decisions that affect myself and those closest to me.

Are you clear on your values? Take a moment to jot down what you think they are. How many did you identify? Taper down the list until you have what you would identify as the three most important. Is the way you currently make your decisions and live your life in alignment with these? If not, can you imagine how might it be?

Symbol Exploration: Compass

A COMPASS is a magnetic device that identifies true north used for navigation. Compasses date back thousands of years, and before being utilized in navigation it is said they were used as a divination tool in ancient China.

Many compasses feature a cross indicating the four major directions. Some feature a cross toile, also known as cross roses, with four, eight, sixteen or thirty-two points of direction. The compass rose, a variation of the equal-armed Greek cross, is said to be a sacred symbol for invoking the powers of the four corners of the earth.

What is your relationship to compass? Do you know the direction of your true north?

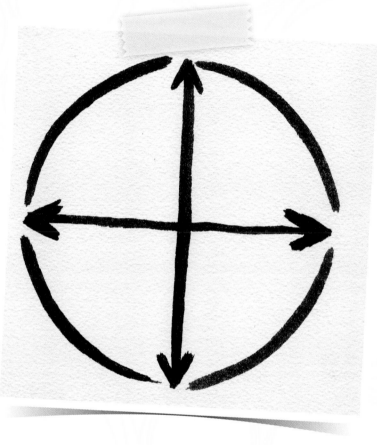

Color and Value Wheel

I love the quote here. A compass is a scientific instrument with four points used to guide someone, to offer clear geographic direction. When we aren't dealing with geography, North, South, East and West are of little use to reference in the decision-making process. Take a few moments to identify something that is—your top three values. We will create a color wheel inspired by them. Just as one color influences the others it interacts with, in life your values do the same.

What You Need

- compass
- paint pen, white (Posca)
- pencil
- permanent black markers: varying line widths
- ruler
- water container and water
- watercolor brush: size 10 (Royal Aqualon)
- watercolor paints: primary colors (I used Winsor & Newton's Cadmium Yellow Deep, Cadmium Red and Cerulean Blue.)
- watercolor paper, cold-pressed, 140-lb. (300gsm) (I used an 8" [20cm] square Arches watercolor block.)

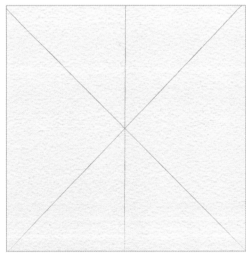

1

Find the center of your square piece of paper by drawing a diagonal line from one corner to the other. Repeat this process on the opposite corner. The intersection is center. Mark one more line from the center top of the paper to the center bottom.

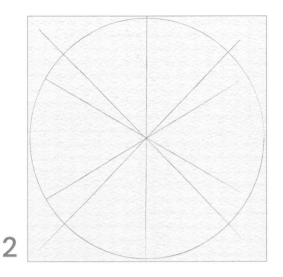

Take your compass and anchor the point in the center. Draw a circle that fills up most of the page. Keeping your compass set to the same size, anchor it at the point where your center line intersects the top of the circle you just drew, and make a small mark on the circle line to the left and the right. Repeat this process from the point where the center line intersects the bottom line.

Using a ruler, draw a line from the mark in the top right quadrant of the circle to the bottom left quadrant. Repeat this for the alternate two marks, finishing with another X mark.

2

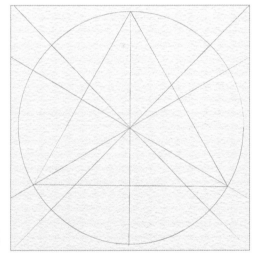

Draw a line between the two bottom points on the new X. Draw a line between each of these points and the center point at the top of the circle. You now have a triangle with a line intersecting the center on each side. These points will serve as the center points for the three circles you will now draw.

3

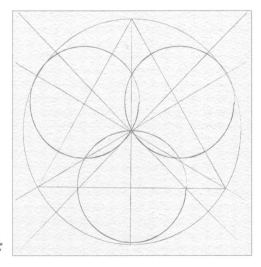

Anchor your compass to the first point and adjust your compass to the distance from this point to the outside of the big circle. Draw a circle. Repeat this process on the other two center points to create three intersecting rings.

4

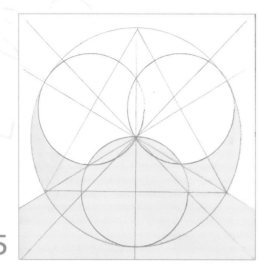

Starting with your yellow paint and a wet brush, lay down an even layer of color, filling one circle and the space extending beyond the circle on each side as seen in the image. Let this section completely dry.

5

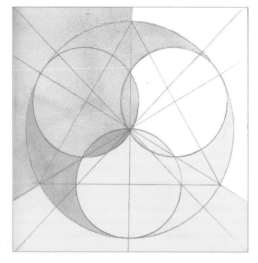

Once the yellow paint has dried, repeat the above process with the blue paint in a second circle.

6

Once the blue paint has dried, repeat the above process with the red paint in the third and final circle.

When you finish, your entire page will be full of color. You have just created a color wheel with the three primary colors—red, yellow and blue—and where they overlapped, three new colors—orange, green and purple.

7

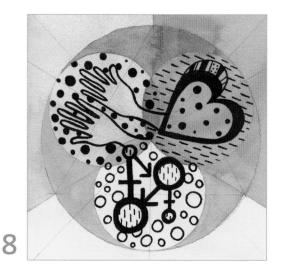

Take a moment to recall the three values you identified at the beginning of this exercise. (I chose family, love and authenticity.) Assign one circle for each item and create a symbol depicting it. The symbols can be representative or completely abstract; they only need to have meaning for you. Using a black marker, draw each symbol in the center of the associated circle. Allow the symbolic images you draw to fill each of their circles, creating an overlap of line and pattern just as we allowed the colors to overlap. Use varying marker sizes to create different line weights and visual interest as you work.

8

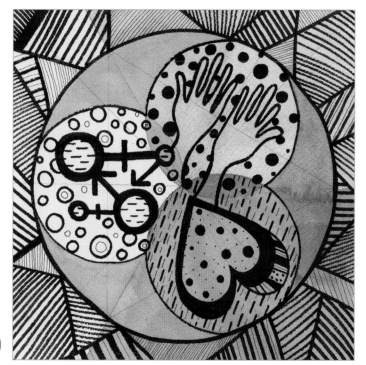

9

Fill the surrounding areas with whatever small marks feel good to you. I chose to leave the space outside of the three rings but inside the greater circle quiet and then fill the remaining space outside of the circle with a linear pattern. Use your white paint pen to highlight a few areas.

Take a moment to reflect on the items you chose to depict and consider how one influences the other. Much like the circles on the page and the watercolor washes you laid down, everything is connected and related to everything else.

KATHRYN COSTA

Kathryn Costa is another creative kindred working regularly with the circle. Author of *The Mandala Guidebook*, she has a secret passion project surrounding true north, so it was clear she would have something to share in this section.
Interestingly, she created her own true north compass mandala completely separate from my exercise, which just illustrates how well the mandala lends itself to this type of exploration!

100MANDALAS.COM

Finding My True North

Most of my life I had been a "good girl." I followed the rules and made decisions based on what would please my dad, mom, teachers and friends. When I had my son I became the "good mother" and my focus shifted to what was best for him. Over the years, I seemed to have lost myself in the process. It wasn't until I began blogging at age forty that I discovered my voice. I followed my curiosity as I experimented with different art techniques and mediums. It was truly the first time that I was making decisions based on what pleased me and not anyone else. I shared my creative life one blog post at a time. I discovered that people from all over the world enjoyed what I had to say.

The focus of my creative work these past couple of years has been revolving around the circular designs known as mandalas. When I create, I like to work intuitively. I listen to my body as I follow my thoughts, ideas and memories. I notice what delights and intrigues me. It is in this quiet time of creating that I find my "true north," a path that is uniquely mine. While I may share a similar history, education and interests with others, I've discovered that I'm one-of-a-kind and when I honor and put into practice my talents, values, ideas and style, I'm traveling in the direction of my true north.

While a sailor will use a compass to navigate to find north, my compass is internal. I use the quiet time of creating as an opportunity to check in and reflect on different areas in my life: my career, personal or work relationships, dreams, project ideas, etc. I observe my body: Does it feel energized or is it tensing up? I explore whatever captures my attention. I notice little signs and synchronistic events showing up in my daily life. I trust my instincts.

Each mandala is more than a pretty picture; each one tells a story. The story reflects either the moment it was created or a memory from one's past that is showing up and wants to be heard. Carl Jung, Swiss psychiatrist, introduced to the West the idea of using mandalas to observe our internal landscape of ideas, feelings and memories. He believed that our subconscious and conscious minds were always seeking balance. Through our intuitive work with mandalas we can learn more about ourselves and our relationships, and use them as navigational devices to heal, grow and discern our true north.

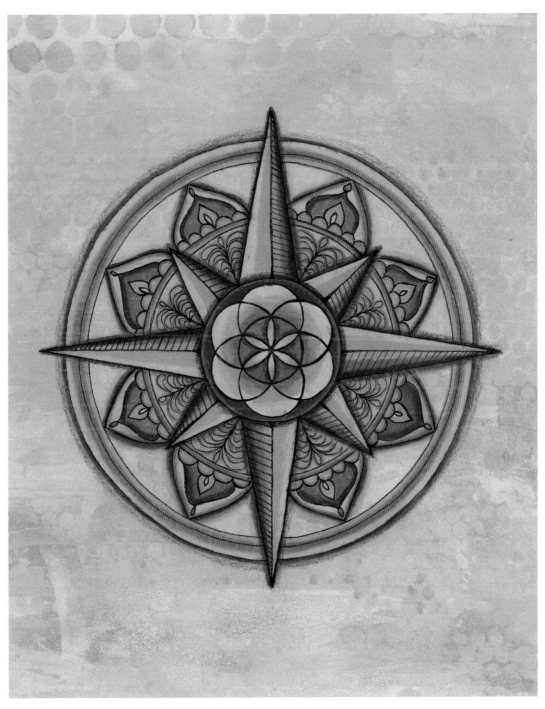

To create my true north compass I started by drawing the traditional points in each direction. At the center I drew the Seed of Life, a pattern found in sacred geometry. I added flourishing feminine forms evocative of growth around the very masculine triangular shapes. In the "petals" around the perimeter are drawn little shapes that look like flames to represent one's inner light. My word for the year is *luminous*. When I look at my true north compass, I am reminded to look within, to follow my curiosity and to trust that my intuition will guide me. I trust that my passion will light the way.

Materials used: acrylic paints for the background, Micron Fineliner pen, colored pencils

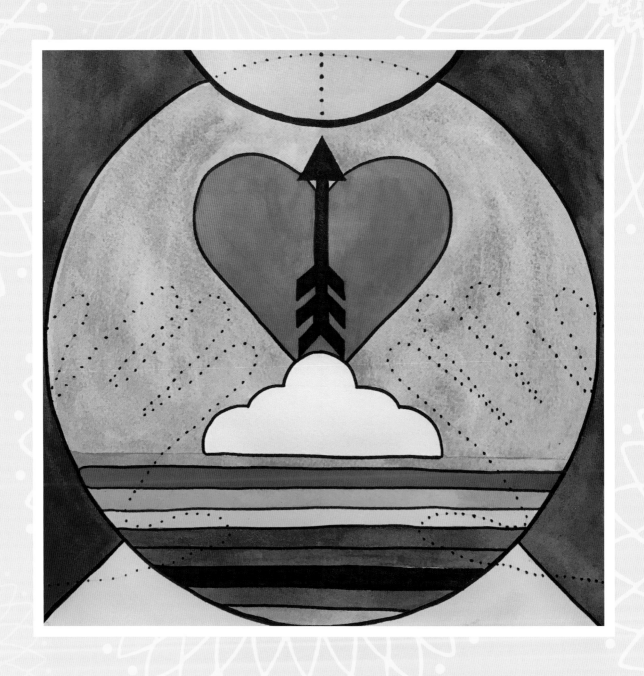

" *There is no greater agony than bearing an untold story inside you.* —MAYA ANGELOU

The Circle as Catharsis

Mandala-making is a powerful tool for catharsis, for release. An artistic approach to letting go! Jung stated making mandalas was "a safe refuge of inner reconciliation and wholeness." To sit down and draft a circle on the page then fill it almost always has a calming effect.

To sit down and do this with the intention of processing a painful memory or event can also be incredibly therapeutic. The sacred geometry of the mandala coupled with creative expression truly does feel like a safe refuge on the page to reconcile whatever bothers you.

Somehow it seems offering the circle as a container for people to express themselves within, around or radiate from has a profound effect. The process is not only therapeutic, but when we allow it to be, the process can also be cathartic. Creative expression allows for clarification and purging of emotions. If we choose the emotions, experiences or memories we would like to reconcile internally, the circle creation can assist.

The process of creative making allows us to move through our grief and sorrow. The circle provides a tidy visual container that helps us feel safe to dive into the journey.

All the Tears You Never Cried

Years ago a woman told me, "All the tears you never cried are waiting for you and they are heavy." At the time I'm not sure I fully understood what she meant but the comment stuck with me. It scared me a little. As time passed I started to understand it. I began to see that to ignore one's sorrow in the midst of a painful experience, big or small, is to continue to carry the sorrow with you. At some time you will have to release the internal weight of it.

This simple painting exercise of tears in a circular shape is designed to create space to consider what exactly you might need to let go of. Whenever I write *catharsis* or *release*, my mind transforms either word to *real ease*. Finally letting go of old stories, sorrow and heartbreak feels good. Old stories can create feelings that are heavy, and when you can release them, even a bit at a time, real ease is what you find yourself moving closer to.

What You Need

acrylic artists' inks: three analogous colors (I used Daler-Rowney's Indigo, Turquoise and Velvet Violet.)

black ink

pencil

water and water container

watercolor brush: size 10 or smaller (Royal Aqualon)

watercolor paper, 6" (15cm) rough circle

1

Lightly sketch out overlapping tear shapes filling the entire circular paper shape.

2

Wet your brush and paint a clear wash of water on all of the teardrops that are not touching one another directly. Using your turquoise ink dropper, place a few drops of ink in each wet tear and watch them spread across the water. Allow these washes to fully dry.

3

Repeat the above process, being mindful to not paint any two teardrops that touch each other if they are both wet. On these drops, place a mix of both turquoise and indigo ink into the washes.

4

Repeat the above process on the final teardrop but place a mix of turquoise, indigo and purple ink drops. This single area of color creates contrast in the painting and provides a focal point.

5

Once all of the teardrops have dried, using your brush and black ink, fill in all of the white spaces surrounding the tears.

Without a source are tears just rain? This piece expands upon the previous catharsis exercise and serves as a bit of a self-portrait. The tears layer one upon the next and fill the space of the two-dimensional shape. The woman, eyes closed, with hair flowing just like the tears, looks to be in a state of tranquility as she releases.

The color blue further signifies calm and tranquility.

On Remembering

WHEN I FIRST STARTED teaching the Story Circles process, it was clear to me through personal experience that making mandalas soothed me in ways other activities didn't. I loved using them as a means of capturing happy stories, of exploring my beliefs and desires and of revisiting the excitement of the immediate past or my desired future. It didn't occur to me it would be helpful to use the process to memorialize or process things from the past.

I was chatting with my close friend Robin Hallett, and she shared a mandala she had created of her father when she found out he had passed away. I knew then I had to try the same thing to explore the loss of my own close loved ones.

I knew this but I didn't do it. I was scared. I wanted to start with exploring memories of my beloved stepfather. He was a huge part of who I am and continues to be today. When he died, it hurt immensely. It was hard to handle. I attempted to shut down my feelings, moved forward and very rarely, if ever, look back.

The problem with doing this was in shutting down the painful memories it became difficult to access any happy ones. For a long time I believed trying to ignore any memories was easier than addressing the heartbreak.

Eventually I started to work on this Story Circle and while I was scared to death, in the end, none of the sorrow I had carried so long mattered. It wasn't actually part of the story of him, it was just the story of his passing. As I sat with the intention of conveying and releasing my grief for him, many great memories rose to the top.

In making this memorial mandala to get to the good memories, I was terrified of revisiting a lot of bad ones like a lifelong battle with diabetes, amputations, quadruple bypasses and more. I realized as I drew my mandala and started thinking about all of the pieces of Denny that I could remember and wanted to memorialize, the ugly stuff popped up first. As it did I was able to say, "Nope, that wasn't Denny." He wasn't the medical situation, he wasn't the challenges or the diabetes; he was so much more.

He was hunting and Old Fashioneds, rifles and golf clubs. He was Saturday carwashes (EVERY week because he LOVED a clean car). He was cowboy boots and pickup trucks. In contrast he was pink pants. He was hot dogs and shamrocks. He was all of this and more—so much more.

Do you have any old stories you carry around that feel painful to look back on? Creativity is an amazing tool for revisiting and moving through such things. When you feel ready, the circle as a container can be a wonderful format to revisit these stories. Who will you memorialize?

Symbol Exploration: Peace

A FAIRLY contemporary symbol, the internationally recognized peace symbol was designed in 1958 by Gerald Holtom for the British nuclear disarmament movement.

A combination of the semaphore signals, a system of people bearing flags to communicate, for the letters "N" and "D," it stands for "nuclear disarmament."

Holtom wrote about the creation of his idea: "I was in despair. Deep despair. I drew myself: the representative of an individual in despair, with hands palm outstretched outwards and downwards in the manner of Goya's peasant before the firing squad. I formalised the drawing into a line and put a circle round it."

Have you ever been in despair, arms outstretched? Where did you find peace?

Memorial Mandala

Creating a memorial mandala is a wonderful exercise for revisiting old memories, happy or sad. It can explore a person, a moment, a place. Here is a memorial mandala I did celebrating the friendship my brother and I shared as children. He was my partner in everything when we lived out on the prairie and shared the red wagon pictured here. Once I decided to use this photo I started remembering other details of this time such as the sweeping blue skies on the horizon and little orange wildflowers that used to pop up in the spring and summer and that I loved to gather on our adventures together.

Choose an image of a person, time or place you would like to spend some time remembering and follow along.

What You Need

acrylic matte medium

balsa wood panel, 8" x 8" (20cm x 20cm)

compass

foam brush

images to represent your memories

paint pens: colors of your choice (I used Posca's red, yellow, light blue and dark blue.)

pencil

ruler

scissors

spreader (old gift card or popsicle stick)

water and water container

watercolor brush: size 10 (Royal Aqualon)

watercolor paints: primary colors (I used Winsor & Newton's Cadmium Yellow Deep, Cadmium Red Medium and Cerulean Blue.)

1

Gather images that you would like to include in your memorial mandala. Create laser photocopies or printouts on regular copy paper. Scan your images and crop them to the shapes you want in the finished piece. You might want to create multiple copies of certain elements that you may find you want to repeat in the finished mandala.

For this piece I cropped the central image into a circle and created multiple copies of the orange wildflower. This provides a cutting guide for me as well as consolidates images onto one page, saving both paper and ink/toner in the final print.

2

After cutting each element to size, lay them out creating the image composition you would like to transfer to the wood block.

Using a foam brush, coat your wooden panel with a thin, even layer of matte medium and immediately place your images facedown on the board and use a spreader to adhere the images from the center out. Be sure to smooth the entire image to the surface of the board and remove any air bubbles.

Let the board dry completely. (This can take several hours. You can leave it for longer than this and return to the project when you are ready.)

3

Dip your fingers into the container of water and begin rubbing their pads back and forth over the surface of the paper. Do not use your nails for this process as you will remove part of the image. Continue to dip your fingers in water so they are continuously wet as you rub. The pulp of the paper will begin to break down and rub off, revealing the panel beneath with the image transferred from the page into the dried matte medium. Continue rubbing the board until all of the paper pulp is removed. You may find as it dries you see a white film appear; this is more pulp, so wet your fingers and rub a little more.

Note on my board there are several areas of my image that did not transfer due to air pockets between the board and my laser printouts. I liked the distressed aspect of this and felt they added to the aged nature of the piece. But if you don't like this look, remove all of the bubbles before the matte medium dries.

Mix some colors to create those that appear in your imagery and use it to fill in the blank areas. Here I mixed some red and yellow to create the orange of my flowers and I used some blue to repeat the color of the sea.

4

5

Identify the center of your square with small light pencil marks along your ruler laid diagonally corner to corner. Anchor your compass into the center and draft various circles, creating a mandala on top of your image transfer. Use paint pens to trace the lines or use them as a guide for creating various patterns surrounding your central image.

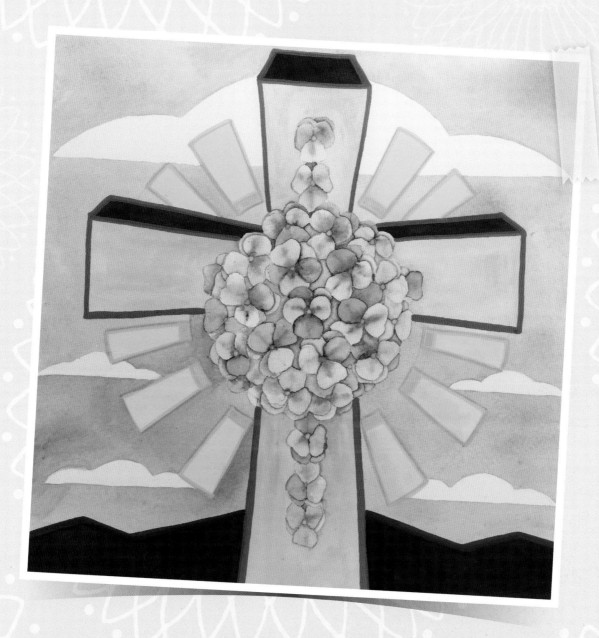

This painting was started the day my beloved Mam-mam passed. It was to serve as a memorial and an opportunity for me to process what had been an intense few days leading up to her death. There was beauty and sorrow in the experience of unexpectedly witnessing her final days. In her final hours several chaplains came to visit and one began singing "The Old Rugged Cross" at the request of my mom. My mother recalled this being an integral part of services at a base my grandfather had been stationed at decades before. As my uncle arrived from Germany just hours before the final passing, he recounted looking out the airplane window and seeing the same town with the army base my mom had spoken of to me for the first time in my life just hours before.

The cross is festooned with purple violets, symbolizing love and faithfulness, both traits I associate with my grandmother. Sun surrounds the cross, signifying warmth and light, and clouds remind me of the heaven to which she believed she would return. Finally mountains flank the bottom, symbolizing the Rockies, which served as a backdrop for a good part of each of our lives.

ROBIN HALLETT

Robin is my dear friend and favorite playmate. Over the years we have discussed the idea of circles, creative expression and art as catharsis. As mentioned previously, it was during one of our earliest conversations on this topic that I realized the power of creating a memorial mandala. Here is a bit about how the circle plays a role in her creative work.

ROBINHALLETT.COM

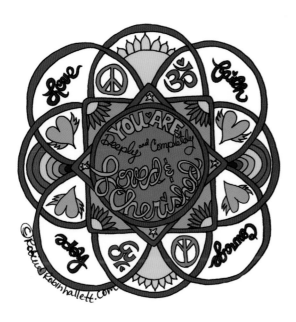

Circle as Space for Processing

I started drawing the day I found out my dad had died. I had been studying *The Tibetan Book of the Dead* and was particularly fascinated by the sand mandalas the Buddhist monks create to transmit positive energies to the environment and to the people who view them, often meditating on divine energies as they work and asking for blessings. And so I decided to create a mandala for my dad. The monks create their mandalas from sand. I didn't have sand but I had crayons, markers and construction paper back from when my stepdaughters were little. I began to trace circles onto the paper using a compact disc and the box it came in, and I quickly found the process soothing to all the waiting-for-more-news stuff that happens when someone dies.

I drew in the spaces all of the things he loved. His garden, his pets, his study of herbal remedies, his relationship with Spirit. I had no idea at the time how powerful it would be to do this for myself and for my dad. It was cathartic. I could feel the blessings going out to him and to me, and to our entire family.

I see circle as a container; it's a sacred space to hold and be held. When we allow ourselves to be present in the circle, we are offered a space to experience expansion but also remain anchored. Circle creates a sense of belonging; so much of our experience is determined by whether we consider ourselves to be in or out of the circle, on whether we believe we are welcome or unwelcome. I often remind myself to intentionally choose inclusion and welcoming, especially when I am feeling anything but.

Peaceful Journey '06 Robin Hallett

Circle provides the safe space to process what I am experiencing. I often will draw as my way to process what is happening in my life. Many of these drawings came from times when I was experiencing difficulties, and the process of drawing always helped me get clear again. I have found forgiveness for those whom I never thought I could forgive. I have found so much love and compassion for myself. Usually I find that I receive powerful guidance as to what steps to take in these creative sessions, too. There is a wisdom in each of us, and when we step in and allow ourselves to be held in that safe space, the healing can be powerful.

*Design is the application of intent —
the opposite of happenstance, and an
antidote to accident.* —ROBERT L. PETERS

The Circle as a Tool for Intentional Design

Line, shape, form, value, color, pattern, texture—these are the elements and principles of design, the building blocks. When you are familiar with them and how one informs the next, you can create with intention. You can take responsibility for what you create, understand how it was accomplished and how you can do it again or how you might change it the next time. Like so many things, this seems to be a metaphor applicable to life.

The circle offers you a container to explore the elements and principles of design and how you can work with them. Learning to understand each element and how one informs the next is important work. Now, entertain the possibility that there are similar elements when it comes to the design of the world you live in and how you move through it. Sometimes creating on the page is just practice ground for the great round that is your life.

Elements and Principles Mandala

In addition to line, shape, form, value, color, pattern and texture as elements in design, the principles of balance and contrast are also important to communicating in a visual language. This mandala allows you to explore each one and see how one informs the next and how each only exists in relationship to another.

What You Need

- black ink
- compass
- pencil
- permanent marker, fine point: one color (I used burgundy.)
- permanent markers, black in varying line widths
- ruler
- water and water container
- watercolor brush: size 06 (Royal Aqualon)
- watercolor paper, cold-pressed, 140-lb. (300gsm) (I used an 8" [20cm] square Arches watercolor block.)

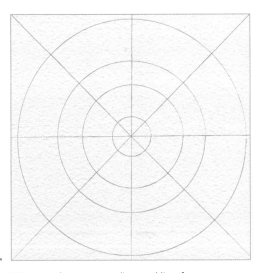

1

Using a ruler, create a diagonal line from one corner to the other. Repeat this process for the opposite set of corners. This has identified the center of the page. Now identify the midpoint on each edge of your sheet and connect these points to divide your page into eight segments.

Anchor your compass into the center point and draft six concentric circles with radii measuring: 3¾", 3½", 2¼", 2", 1⅝", and ¾" (10cm, 9cm, 6cm, 5cm, 4cm, 2cm).

2

Using the circles and intersecting lines as a guide, vary the edge on one circle to create variety. I chose the second circle from the middle and created a small curve at the top of each one, resulting in a circle with a large scalloped edge.

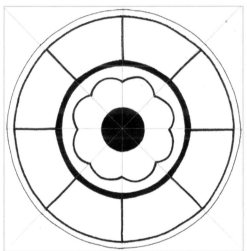

3

Using black markers, begin inking the lines that you want to be visible in your final piece. This is the element of "line" functioning within your circle. Play with various line widths to create visual interest. As each line comes full circle and meets itself, notice the shapes you create.

Using the same black marker, fill in the innermost circle line. You now also have a nice solid "shape."

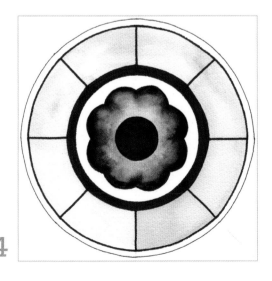

4

Dip your brush in water and fill in the scalloped circle shape with a clear wash. Dipping just the tip of your brush into black ink, run it along the edge of the shape, allowing the black ink to spread across the wash. The result that occurs is shading from light to dark, creating the illusion of dimensionality or "form."

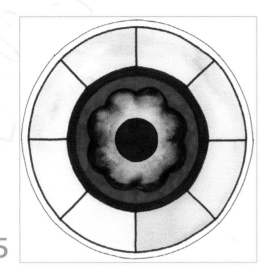

Dip your brush again in the now ink-tinted water and use this to create a gray wash that fills the second to outer-most circle. You have now created a middle "value" that exists between the black of the pure ink and the white of the page. Using your burgundy marker, fill in the circle area surrounding the scalloped edge. "Color" now plays an important role in the mandala.

5

Using your existing lines as a framework, create repeating elements that surround the circle. You have now created "balance" and "symmetry" within the piece by creating a "pattern."

6

Using the burgundy marker you used to surround the scalloped edge form, create a stippling effect (series of small dots in close proximity) to fill the outer edge. The small pattern you just filled the ring in with creates "texture."

7

8

Using your black marker or ink and brush, fill in the area surrounding the mandala, creating a strong "contrast" between the shape itself and the background.

Pieces of Me

There came a time when everything had changed, yet nothing had,

Where the old pieces, parts of me, remained, and I knew they always would. And for that I was grateful.

However, I knew . . . these pieces needed to be reevaluated, reorganized, repurposed.

This painting, this process, this life

All pieces of me.

Before, now, always

THE QUOTE at the beginning of this chapter stopped me in my tracks the first time I read it. It got me thinking about design on many levels . . . designing everything from a two-dimensional work of art to one's life.

Shortly after reading it I walked out of my studio and into our house, in through our demolished main floor that was under construction, through our overflowing playroom, and down to the basement to do a load of laundry. I navigated piles of clutter, loaded the clothes and in my periphery saw my flat files of paintings and drawings. Decades of history surrounded me.

We were in the midst of paring down, letting go, simplifying. I had been wondering when and how I would approach this with some of my old work. So many papers, just quick studies, but still records of something I needed to capture and was not yet ready to let go of.

I realized there were parts of myself, physical and other, that will always be a part of me: paintings, objects, memories, behaviors. They cannot be released nor would I want them to be. I also realized I could reevaluate, reorganize and repurpose them. I could design a different life with these same elements.

The visual work could be deconstructed then reconstructed into pieces that now better represent me. The objects, memories and behaviors designed into a life that now better serves me and my family, too.

As you look through the spaces that surround you, are there things you're not ready to release but would like to redesign? Do you have old artworks or documents you are willing to repurpose into something beautiful? How is this a metaphor for other things as well?

Symbol Exploration: Recycle

THE THREE arrows making up the symbol associated with recycling are wrought with meaning. The arrows are arranged along a triangle format. The triangle shape represents the reduce, reuse, recycle order for addressing waste. It is said that the arrows themselves signify collecting, processing and manufacturing.

This symbol, designed in 1970 for a design competition by twenty-three-year-old college student Gary Anderson, is a perfect exploration for this section. It reminds us that not everything can or should be thrown away. That with intention we can stop creating excess waste. That we can also break down much of what no longer serves us and re-create it into something new that will.

What parts in your life can you reduce, reuse or recycle? What parts are you better off releasing completely?

Deconstruct to Reconstruct

You probably have old artworks, documents or other papers in your home that no longer serve any purpose. Why don't you use them to redesign something beautiful? We will slice and dice, break or disassemble your items, then create a mandala out of them. As you work through the process, decide what stays and what goes. See yourself designing your future life with the pieces you wish to keep while discarding the elements that are no longer part of you.

What You Need

acrylic matte medium

compass

foam brush

heavy book and wax paper for drying (optional)

old painting or document

paint pens: your choice of colors (Posca)

ruler

scissors

1

Identify a few contrasting areas on the piece you wish to deconstruct. Using a compass, draft various circles to cut out. I cut out a green one with a radius of 2⅞" (7cm), a lighter one with a radius of 2" (5cm), a very dark one with a radius of 1¾" (4cm) and the central and lightest one taken from my favorite part of the old painting with a radius of 1¼" (3cm). Continue deconstructing the old work by cutting out variously shaped pieces to include in your mandala. I cut four larger petal shapes out of lighter areas and eight smaller petal shapes out of darker areas.

2

Coat the back of the three smaller circles using a foam brush and matte medium. Center and glue them one on top of another, creating a series of concentric circles.

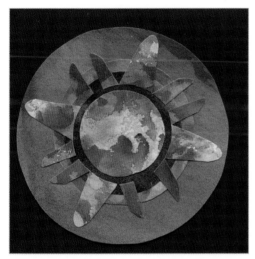

3

Repeat the same process as above and glue down the petal shapes, creating a radial pattern. Once all of the elements have been glued down, I like to place the piece under a heavy book, first covering it with wax paper in case any matte medium has seeped out along the edges. This ensures the paper doesn't curl from the moisture in the matte medium and all of the pieces stay completely glued down.

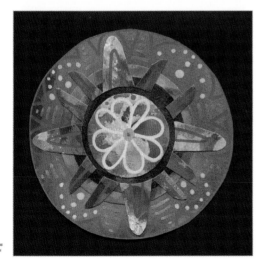

4

After the piece has dried, use your paint pens to add interesting line and pattern elements. I used pink, peach and green to keep a soft and consistent color palette, but you could also opt to use something completely different to create strong contrast.

KATHERINE TOLVE

Katherine Tolve is an artist local to me whom I met when sharing neighboring spaces at an open studio show. A lot of her work revolves around pattern, symmetry and repurposing hoarded materials and turning them into something beautiful. Below she shares a few paintings and their relationship to the circle.

KATARTS.ORG

Circle and Craft

One of the driving forces behind my work is a deep passion for patterns, craft and the never-ending exploration of materials. The circle as a geometric shape often appears in my work; sometimes it facilitates the formation of a pattern, sometimes it is used solely for compositional purposes, and in the instance of *Encaustic Fossils* it is used for both.

If you were to examine a piece of lace through the circular lens of a magnifying glass, what you would see is reminiscent of this painting.

Traditional crafts such as knitting, weaving, crocheting and embroidery all require

understanding and maneuvering through and around a circle creating knots and loops. Incorporating crafts into my artwork and subject matter, I am often confronted with the idea of craft as high versus low art.

The circle often represents the sun, innovation, the self, timelessness and divinity. These symbols are highlighted through my choice in colors and repetitive placement of lace-like shapes subsequently being used as a symbolic tool to help bring value and worth to my imagery and subject matter.

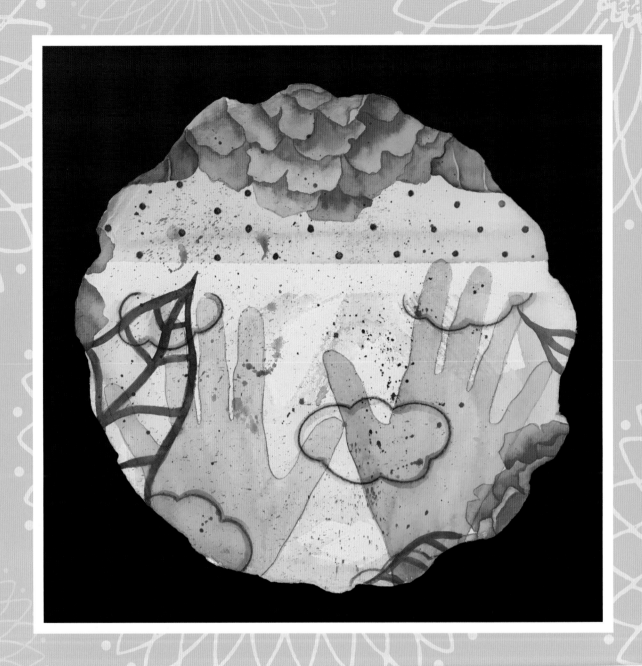

I can teach anybody how to get what they want out of life. The problem is that I can't find anybody who can tell me what they want. —MARK TWAIN

The Circle as a Tool for Manifestation

To make manifest: to make evident or cause to appear. Is it really possible? Can you really put a request out to the universe and expect that it be answered? Is it just that easy, or do thoughts simply identify what you want while concrete actions determine what you get? Perhaps taking action forms the manifestation.

One thing is certain: Before any manifestation, through thought, action or both, you need to determine what you really want. Do you know what that is? What is it you truly desire? Think about it, be specific, write it down, explore it. This is how you begin to create your future story.

Manifestation Mandala

The quote by Mark Twain at the opening of this chapter really sums up the challenge with manifesting. How do you identify what it is that you really want? Often, we can get caught up in the worry that we might change our mind or we might not name everything or we might name too much or that our dreams aren't actually valid. Let's dismiss all of this.

In this exercise, you will create a simple vision board using a circular format. Select one thing you would like more of in your life, anything you want, and create a mandala around it. Gather your magazines or printouts and start clipping.

What You Need

- compass
- glue stick
- magazines or catalog for collage
- paper: your choice (I used an 8" [20cm] square Arches watercolor block.)
- pencil
- ruler
- scissors
- scrap paper for circle template

1

Flip through various magazines or catalogs and tear out images that relate to what you want to call in more by creating this mandala. They may be photos, illustrations, words or colors—anything that appeals to you.

Draft a circle on your scrap sheet of paper to serve as the template or base of your mandala. Cut the shape out. Locate the center on your base sheet and draft an identically sized circle on it.

2

Begin gluing down pieces, working from large to small, onto the circle shape. After each layer, trim the excess image away by flipping the circle over and using it as a guide. Coat the back of the finished mandala and glue it to a base sheet.

Side note: The funny thing about vision boards is they sometimes start to work even as you are working on them. I decided to focus on calling in more ease to my life. I sat and flipped through magazine after magazine. I was finding images that spoke to me, but I really, really wanted to find the word *ease*! After a dozen magazines I decided I didn't need to be that specific and would rely simply upon the pictures I had selected. After I glued everything down to the circle I still felt something was missing. I looked down at my lap where a scrap of text lay: two Es, an A, an S. I could make my own *ease*, and so I did, and so I will.

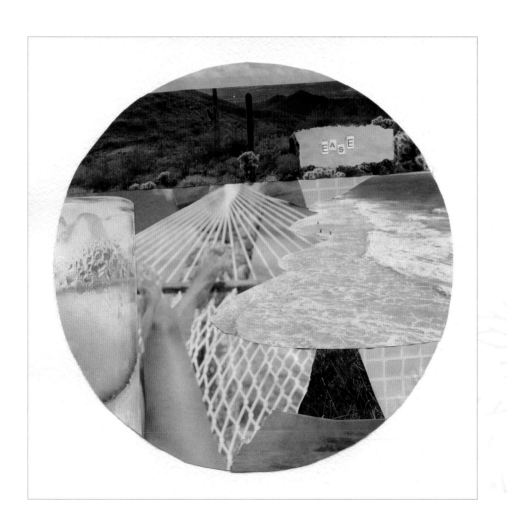

To Make Manifest, Quite Accidentally

A FEW YEARS ago I decided I wanted to commemorate my late brother. I started to think about how I would like to celebrate him, which led to a myriad of other questions. The answer I kept coming back to was "Love." How did I move on after his passing? Love. How can I celebrate him today? Love. What do I want to put out into the world? Love. What exactly is it that I most want to receive? Love.

I started exploring what a visual expression of love for me might look like. I landed upon sacred geometry and the symbolism of the St. Valentine heart.

I started really focusing on love, talking about it, creating imagery around it. I opened myself up to it and guess what? A lot of things happened and continue to.

In some ways life remained the same, yet drastically changed in the way I experienced it. Love presented itself in abundance. I finally had a solid anchor point from which to work.

My decision that year to "choose love" was not intended to manifest more of it in my life. I focused upon it as the foundation for a show of paintings. I was already quite fortunate in my life and my heart felt fairly full. However, focusing my work, my thoughts, my choices on one topic really forced me to start aligning in all areas. The work is not always easy but it has been powerful.

Choosing love led me to sacred geometry, which led me to making Story Circle mandalas and daily painting, which led me to teaching everything that I love to share with

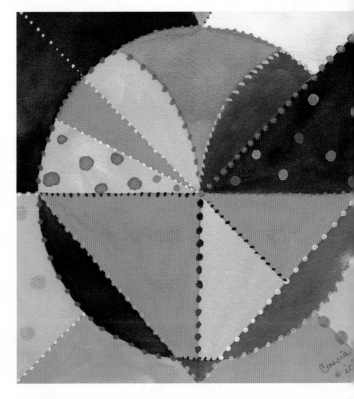

others, which ultimately led to the creation of this book.

Conversely, at other times, I have focused on fear, scarcity or other undesirable things and they, too, have multiplied.

Can you think of instances where you may have manifested something accidentally? Can you choose a single thing today you would like to focus on, calling more of into your life? Are you ready to manifest with intention?

Symbol Exploration: Spiral

A SPIRAL CAN represent the path leading from external awareness to the inner soul and cosmic awareness. Moreover, in terms of rebirth or growth, the spiral symbol can represent the consciousness of nature beginning from the core or center and thus expanding outwardly.

Spirals are everywhere in nature and follow a sacred geometric principle called the golden ratio. Consider flower petals and seed heads, spiderwebs and pinecones, pineapples and cauliflowers, and the growth pattern of tree branches and root systems. On a vast scale, spiral galaxies and hurricanes.

The most meaningful natural spiral to me is the nautilus. Hatched from an egg after a twelve-month period, the nautilus already has four chambers. As the shell grows new chambers, it spirals up and out, following the golden ratio. Each time a new chamber is formed, the body of the nautilus moves forward into it and produces a wall to seal off the older one. The empty chambers regulate its buoyancy as the living creature is able to inject into or remove fluid from them as necessary. The nautilus grows and spirals up and out, it closes off the past as part of its current living space, yet still carries the physical history forward and even calls upon its spiral shell as necessary.

Are there parts of your past you have "sealed" off as you have grown? Do you ever find yourself calling on them for assistance?

Manifestation Spiral

The spiral is a powerful symbol of manifestation and expansion. Make a list of all that you would like to call into your life. Free flowing, without judgement, let 'er rip You may not even fully understand what some of the things mean when you're writing them. Resist judging yourself as you go; there is no right or wrong way. Your desires don't need to make sense to anyone but you. Write out whatever comes to you under the topic of "really want" because everything spills out to show us something. Think about it. Remember: Thoughts determine what you want. This is where it starts. Name it, claim it, call it down.

What You Need

acrylic artists' inks: two colors of your choice

compass

hake brush: 1" (25mm)

paint pens: various colors, including white

pencil

ruler

water and water container

watercolor paper, cold-pressed, 140-lb. (300gsm) (I used an 8" [20cm] square Arches watercolor block.)

1

Find the center of your square piece of paper by drawing a diagonal line from one corner to the other. Repeat this process on the opposite corner. The intersection is the center. Anchor your compass to the center and open it to create a circle that fills the entire page; for my page that was a radius of 4" (10cm). Begin contracting your radius ½" (1cm) at a time and drafting smaller and smaller circles until you return to your center point.

Using the concentric circles as your guide, begin laying in lines attaching one to the next, creating a spiral path. Erase any lines that are not part of it.

Lay a clear wash of water with your hake brush over the entire page. As it lies on a flat surface, drop several drops of one ink color into the center of the sheet and watch it radiate out. Drop a couple drops of your second color in each corner and watch as the ink radiates in to meet the first color. If you want to manipulate the wash so it appears more even, begin dragging the brush along the spiral path, mixing the colors on the page. Allow this layer to dry completely.

Trace the spiral line with a paint pen.

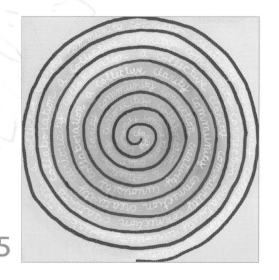

Retrieve the list you made earlier of everything you wish to call down into your life. Refer to it as a guide as you use a white paint pen within the spiral path to write the words that call out to you. If you run out of words before reaching the end of the spiral, just repeat those you have already selected.

5

6

Gather your paint pens and create dots, lines or other marks over the words, working from the center of the spiral out. I like to view this part of the process as the final sealing of your requests to the page and sending them out into the universe.

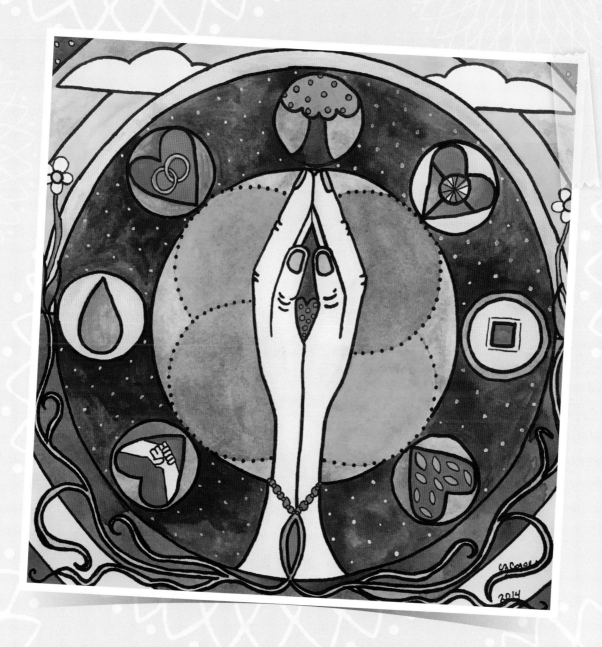

A manifestation mandala I created after first reading and completing the *Lotus and the Lily* by Janet Conner. Full of symbolism both universal and personal, this painting was the first time I really sat with the possibility of the mandala as a tool for full-fledged manifestation and spent more than thirty days preparing for and creating it.

JANET CONNER

I was directed to the work of Janet Conner after creating and teaching my first round of the Story Circles e-course. My friend Robin kept insisting I had to read Janet's book *The Lotus and the Lily*. It was truly life changing. I have since worked through the process on three separate occasions, each one bringing immense learning and value.
If you are truly interested in the possibility of mandala-making as a tool for manifestation, her work deserves your time and attention.
JANETCONNER.COM

Mandala as a Tool for Manifestation

When *Writing Down Your Soul* came out in January 2009, I traveled the country teaching thousands how to shift their writing from journaling in the alpha brain-wave state to soul writing in theta. The honorariums were tiny and the expenses soon overwhelmed my credit cards. By November, I was bankrupt. A friend recommended a bankruptcy attorney, but he wasn't available until February. In anger and pain, I turned to my voice on the page and demanded to know what good could come of bankruptcy!

On the page, I was told to write at the deepest soul level in December devoting one week to preparation, one week to looking back at the life I'd already created and one week to forgiveness. In the fourth week I could finally look forward to the year I wanted to create. But after three weeks of deep soul writing, I no longer wanted any of the things I had thought were so important.

I fell asleep on December 31st confident I was ready to call in a beautiful 2010. But the next morning, instead of diving into my planned at-home retreat, I picked up a little yellow book, *You Are Here*, by Thich Nhat Hanh. At 1:00 P.M., I tumbled into the sentence that changed my life: "The Buddha said when conditions are sufficient there is a manifestation." As the meaning sank in, I began to scream, "Oh my God! Everything we think we know about manifestation is 180 degrees off! It's not about the manifestation! It's about the conditions!"

I grabbed my journal and asked one of the most important questions of my life: What are my conditions? The six ways of living that nourish my beautiful life poured through my hands. I wanted to capture them visually, so I traced a plate on a piece of paper with a dot at the center of the circle representing the Transcendent. I drew a six-petaled lily around the dot with a keyword for each condition on each petal. I drew little stick figures representing the things I wanted in 2010: agent, contract, financial flow, virtual assistant, radiant health, etc., but I placed those things where they belonged—on the periphery.

Every morning in January, I stood in front of my mandala and said to Spirit, "Here, you take care of everything I need; I will focus on

2015

PERFECTLY CONTAINED

UTTERLY VAST

CONSCIOUS INTENTION

Sophia In Me
△△△

2015: A year that brought two book contracts, a new kind of adult coloring book, the Mystical Fools Society, 100,000 downloads on "The Soul-Directed Life" radio show, the Love Loving Love prayer/meditation, a huge future writing assignment and more.

living my conditions," then I chanted them aloud. My life continued as it had: I showed up at bookstores, I taught soul writing, I wrote newsletters. But people started giving me hundreds of dollars when I spoke and sending letters of gratitude stuffed with money. My new telecourse filled effortlessly and one woman even double registered and asked me to give the second as a gift.

In February the bankruptcy attorney told me to come back when I was no longer bank-rupt. I haven't been back. And everything on that mandala came to pass and more.

I continue to make an Intention Mandala every New Year's Day. But I no longer put anything I want on the periphery. I have found that the universe does not need me to announce what I need—and what I think I need is way too small anyway. So I just focus on living my condi-tions, and without fail each year brings wonders I could never have imagined.

Conclusion

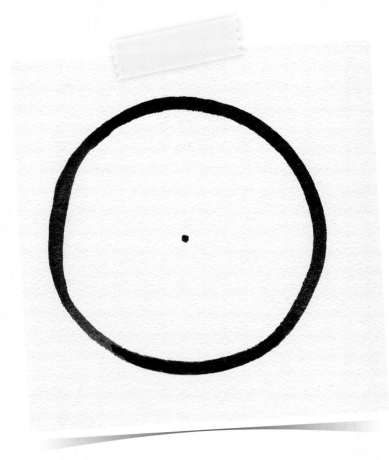

IN THE PREVIOUS chapters you have connected to your authentic voice, explored creative expression and soothed your spirit while engaging in painterly play within the sacred circle.

You have created beautiful work centered around or created within the circle. I hope that you have found the beautiful and sacred within yourself.

The same solid circle that appears as the spark of creation can appear as a full stop period at the end of a sentence. However, the line that creates the container of the circle has no beginning and no end. Let this practice be the same. Return to it as often as necessary, revisit each exercise and marvel at the difference in results.

This stunning blend of geometry, art-making and visual storytelling is a part of your toolbox now. Carry it with you from this moment forward.

With open hearts and inquisitive minds, let us continue!

Index

a content + ecommerce company

Other fine North Light Books are available from your favorite bookstore, art supply store or online supplier. Visit our website at fwmedia.com.

21 20 19 18 17 5 4 3 2 1

DISTRIBUTED IN CANADA BY FRASER DIRECT
100 Armstrong Avenue
Georgetown, ON, Canada L7G 5S4
Tel: (905) 877-4411

DISTRIBUTED IN THE U.K. AND EUROPE
BY F&W MEDIA INTERNATIONAL LTD
Pynes Hill Court
Pynes Hill
Rydon Lane
Exeter
EX2 5AZ
United Kingdom
Tel: (+44) 1392 797680

ISBN 13: 978-1-4403-4832-7

Edited by Tonia Jenny
Designed by Clare Finney
Production coordinated by Jennifer Bass

METRIC CONVERSION CHART

To convert	to	multiply by
Inches	Centimeters	2.54
Centimeters	Inches	0.4
Feet	Centimeters	30.5
Centimeters	Feet	0.03
Yards	Meters	0.9
Meters	Yards	1.1

Dedication

For Steve, Millie and Calvin, who bring depth and beauty to the mandala of my life.

Acknowledgments

First and foremost, to you, for reading, I am eternally grateful.

To my husband and children who constantly support me in my creative endeavors and rarely bat an eye when my projects overtake the house.

To my mom, Deb Derrington, who let me trace her dishes all those years and never said a thing.

To my sister, Megan Espinoza, who's always cheered me on.

To my grandma, Sarah Eileen Zamecki, who has always seen me as an artist and never hesitated to tell anyone even if I occasionally forgot myself.

To Susan and David Mazure for their endless support on so many levels.

To Mike and Emily Rosenbush for being our constant cohorts.

To Dennis Francen who has always been near, championing my work as an artist.

To Timothy J. Clark, a mentor and friend in both art and adventure.

To Frank O'Cain for guiding me to self-connection through creative expression.

To Susan, Barbara and Michael Murphy. It takes a village to raise a child; to raise children while writing a book takes something far more, like the Murphys.

To a special group that came into my life at the same time my Story Circles surfaced: To Robin Hallett for a friendship I didn't know was possible. To Cynthia Morris for walking along this journey with me and keeping me on path. To Jonathan Fields for helping to remind me the path was even there and helping me to clear it. To Marc Winn for giving me the permission to "never, ever change" even while moving forward. To Eric Kim for seeing me as a storyteller.

To all of my teachers and students over the years who keep the creative conversation going.

And finally, to Tonia Jenny, my editor, who ignited a dream in me I didn't know was there and stood close by tending it through this amazing process of creating a book.

Thank you!

About
Cassia Cogger

Cassia Cogger is an artist and teacher living in central Connecticut with her husband and two young children. She is inspired to create artworks, creative courses and experiences that allow individuals to enter into greater relationships with their surroundings, becoming present to that which is most essential for them. As much as she is excited by color, shape, pattern and beauty, she is more excited by the creative process and what it reveals.

Her work has been featured at the National Academy Museum of Design in NYC, in *Watercolor Artist* magazine as a rising star as well as in a host of other galleries and private collections.

Learn more about Cassia and her work at www.cassiacogger.com.

Ideas. Instruction. *Inspiration.*

Receive FREE downloadable bonus materials when you sign up for our free newsletter at **ArtistsNetwork.com.**

 These and other fine North Light products are available at your favorite art & craft retailer, bookstore or online supplier. Visit our websites at **artistsnetwork.com**, **northlightshop.com** and **artistsnetwork.tv.**

Get your art in print!

Visit **artistsnetwork. com/category/ competitions** for up-to-date information on North Light competitions.

Find the latest issues of Cloth Paper Scissors on newsstands, or visit **northlightshop.com/cloth-paper-scissors-shop.**

Follow ClothPaperScissors for the latest news, free wallpapers, free demos and chances to win FREE BOOKS!

144